D0087148

Names on Trees

ARIOSTO INTO ART

PRINCETON ESSAYS ON THE ARTS

ADVISORY COMMITTEE: MONROE C. BEARDSLEY, EDWARD T. CONE,
HOWARD HIBBARD, EDMUND L. KEELEY, A. RICHARD TURNER

Names on Trees
ARIOSTO INTO ART

By Rensselaer W. Lee

PRINCETON UNIVERSITY PRESS

PRINCETON, NEW JERSEY

Copyright © 1977 by Princeton University Press
Published by Princeton University Press, Princeton, New Jersey
In the United Kingdom: Princeton University Press, Guildford, Surrey

All Rights Reserved

Library of Congress Cataloging in Publication Data will
be found on the last printed page of this book

Publication of this book has been aided by a grant from the
Paul Mellon Fund of Princeton University Press

This book has been composed in Linotype Caslon Old Face

Printed in the United States of America

To Stella Garrett Lee

Contents

Preface

This essay on the pictorial illustration of a famous episode of Ariosto's *Orlando Furioso* is in line with my other studies on the bond that unites or, at least, once united, poetry with painting. It was read in part before the American Philosophical Society in Philadelphia on November 14, 1974, and matter contained in it has been used in various lectures on Ariosto in art in this country and abroad. Collecting the photographic documentation began many years ago when I explored galleries and print collections in Europe on a grant from the American Council of Learned Societies to which I here render belated and hearty thanks. I am also grateful to the Department of Art and Archaeology of Princeton University for several grants-in-aid, and to the Institute for Advanced Study, where, as a visitor during the spring of 1972, I first put together much of the literary and visual material.

Two other studies of mine on the impact of the *Orlando Furioso* on art deal, as this essay does, with the figure of Angelica, though with her earlier adventures. But the story of Angelica and Medoro in a later canto, in which these lovers carve their names on trees, had a larger effect on the history of art than any other in Ariosto's poem. The interpretation by the painters of this human, original, and influential pastoral, is then the main concern of this essay. I am particularly grateful to my old friend and former student, Margot Cutter, of Princeton University Press, for her always expert editing and wise criticism.

Besides particular indebtedness acknowledged in footnotes I wish to thank my friends and colleagues Blanchard Bates, A. Bartlett Giamatti, Roland Frye, Charles Klopp, and Samuel H. Monk for valuable suggestions on the side of literature, and on the side of painting, Felton Gibbons, Denis Mahon, Edgar P. Richardson, Erich Schleier, and Ellis Waterhouse. Erwin Panofsky, a cherished mentor, early encouraged pursuit of the subject. For help in research I am grateful to Ellen Oelsner and to Elaine Banks, who also read the manuscript and improved it with her comments. I am also in-

debted to Kaye Van Valkenburg, to Jane Sloan, who typed the manuscript, and to Jane Mull, who generously helped with the proofs.

This book is lovingly dedicated to my wife.

Princeton, New Jersey
December, 1975

List of Illustrations

Color Plate. Jacques Blanchard, *Angelica and Medoro*. New York, Metropolitan Museum. Photo: Metropolitan Museum

Names on Trees
ARIOSTO INTO ART

1. *Liber naturae*

In the twelfth century the famous poet and theologian Alan of Lille, whose seminal influence on poetry continued into the Renaissance,[1] sums up in three lines of a short poem the idea familiar to the Latin Middle Ages that every creature of the world is a book, and he adds, a picture.[2] It is also, he says, using a time-honored image, a mirror,[3] that is, an image of life which reflects the mind of God who created it. The metaphor of nature as a book, and it is interesting that Alan extends it to include "picture" in a way that foreshadows the later Renaissance association of the sister arts of writing (more precisely poetry) and painting, goes back many centuries; in the Greek world at least as far as Plotinus' beautiful comparison of the stars to "letters perpetually being inscribed on the heavens or inscribed once for all and yet moving,"[4] and these similes, like others in late antiquity, have their remote origins in the very ancient idea of the sacredness of the book and the sense of mystery attached to writing. For this religious respect for the book "we should have to go back," remarks Curtius, "through the sacred books of Christianity, of Islam, of Judaism to the ancient Orient—the Near East and Egypt."[5] It is in the Bible, the sacred volume of the Christian religion, that the grandest imagery of the book occurs. Thus in Revelation we read that "the heaven departed as a scroll when it is rolled together,"[6] an image of cosmic power which Dante remembers when he writes that the Primum Mobile is "the royal mantle of all the volumes of the world" (it is the handsome binding, he means to say, of the celestial spheres it encloses),[7] or that "what is scattered throughout the universe," like loose quires or pages, is bound together in one volume by the power of love.[8]

In the Middle Ages the book of nature, also called by Alan of Lille the book of experience,[9] written by the finger of God and the mirror of his mind, was by definition an edifying book, and like Holy Scripture, of which it is the earthly and manifest counterpart, a *liber sanctae doctrinae*. It was furthermore twofold, a *liber scriptus intus et foris*, to be read both in the human mind and in the sensible world. As we move away from the mediaeval centuries the idea of

nature as a book of sacred instruction tends to become secularized, to free itself of theological connotations; nevertheless, instances of its earlier meaning persist well into later centuries.

Thus John Calvin, Protestant theologian, in the mid-sixteenth century still follows mediaeval tradition when he refers to nature as "un livre écrit en assez grosses lettres" which, since it shows the attributes of God, yields "tant d'enseignements divers."[10] But the sixteenth century also shows a change of emphasis. Paracelsus, a physician and observer of nature and near contemporary of Calvin, makes a novel distinction between written books—*codices scribentium*—and the book of nature or rather the books of nature, *libri naturae*, which have no imperfection "because God himself," as he says in a fine image, "made and bound them and hung them from the chains of his library."[11] Thus the Creator himself is not only the author but also the custodian of the grand library of the world, which is a repository of doctrine no philosopher, above all, no natural philosopher, could afford to neglect. A century later in England another physician, Sir Thomas Browne, in a famous passage speaks of the "two Books from which I collect my divinity; besides that written one of God, another of His servant Nature, the universal and publick Manuscript, that lies expans'd unto the Eyes of all; those that never saw Him in the one have discovered Him in the other"; and he blames Christians who, unlike their heathen forbears, "disdain to suck Divinity from the flowers of Nature."[12] Thus in both of these writers and men of science—and here the spirit of the Renaissance declares itself—the due respect accorded the written word appears to be all but eclipsed in importance by the sense of admiration for the marvelous book of the world. And this—for the Middle Ages have not ceased to cast their long shadow over the minds of such men—is still conceived as written in the "common Hieroglyphicks" of God or of his deputy, Nature, and open for all to read. Even the philosopher Francis Bacon, the prophet of modern science and the inductive method, who stressed the facts of natural history and the data furnished by sensory experience, can declare in the mediaeval manner that God has placed before us "two volumes or books to study" if we would discern his will and power, one the scriptures, the other "the creatures," but then adds significantly that "the latter is the key to the former," thereby revealing the essentially empirical bent of his

mind.[13] In a notable earlier writer, however, the theological idea had already disappeared and the book of nature was no longer conceived as written under the divine aegis. Montaigne still uses the image of the mirror, but the great world is now the mirror of life itself, of empirical not revealed truth, and it is this book which he recommends as fundamental for the education of young men: "Somme, je veux que ce soit le livre de mon écolier."[14] For Shakespeare at the end of the same century, the imagery of the book is pervasive; the face, the eyes, "the secret soul,"[15] the whole person, are books in which one may read the affections and perturbations of the spirit, the inner life of the mind, in short, the quintessential nature of life itself, though now with no precise theological overtones. And if men and women are books in which we may read their thoughts and passions, so is nature around them still a book, and one that can, as in earlier centuries, offer good instruction. In *As You Like It*, as everyone remembers, the Duke, banished by his brother, takes refuge with his loyal followers in the Forest of Arden. Here, away from the artificialities and iniquities of mundane life, in woods that are "more free from peril than the envious court" (this a common theme in Renaissance literature), he and his friends find solace and fortifying doctrine in reading the book of nature. And Nature, now thoroughly domesticated, so to speak, to the Renaissance discovery of the world, here proclaims the old idea that she is a *liber doctrinae* in the fresh, original and observant poetry of a new age. The Duke is her spokesman when he says in a famous passage:

> *Sweet are the uses of adversity,*
> *Which, like the toad ugly and venemous,*
> *Wears yet a precious jewel in his head;*
> *And this our life, exempt from public haunt,*
> *Finds tongues in trees, books in the running brooks,*
> *Sermons in stones, and good in everything.*[16]

The Duke's sensitiveness in adversity to the invigorating and consoling voices of nature occurs in the context of the short involuntary pastoral, "poco tempo silvano,"[17] as Dante had said, that he and his followers are required to live in the forest. At length fortune smiles on them again, their pastoral interlude is ended, and they return to the normal business of life in the city and the court, a life perhaps

less felicitous by Arcadian standards, but, as Shakespeare clearly suggests, more serious and significant. But during their brief sojourn in the country in a pastoral setting of shepherds and shepherdesses (traditional protagonists of an ideal life) where nature is bountiful enough to keep them healthy, and where the young gentlemen who join the Duke are said to "fleet the time carelessly as they did in the golden world,"[18] in this temporary idyll that recalls the Golden Age, nature is not only a good provider, but also, as we have seen, speaks a philosophic language of long lineage. But she has also another voice, her book another page. With the aid of human scribes, she speaks in a lighter vein that is not instructional, but amorous and sentimental. Among the Duke's companions in exile is a gallant young man who has fallen in love with the Duke's daughter Rosalind. Like many lovers in pastoral and elegiac literature, Orlando goes about the forest carving the name and virtues of Rosalind on the bark of trees, a pastoral topos of which Shakespeare here makes considerable fun, as he does of other bucolic conventions. Thus the book of nature, to the Duke a script of genial advice for living in depleted circumstances, becomes as well a series of blank leaves which, inscribed with the thoughts of lovers, is not only symbolically but almost literally a book on whose pages a lover can record the amatory effusions of his heart and the name of his girl. Orlando himself states the case clearly when he says,

> O Rosalind, these trees shall be my books,
> And in their barks my thoughts I'll character.[19]

This charming variation on the grand and serious theme of nature as a book, based ultimately as it is on the normal behavior of youth in love, is of course purely human and terrestrial in character. To view it against the impressive background of religious origin and theological history is indeed *parvis componere magna*. Yet in both the poetry and art (here clearly joined) of the Renaissance and beyond, the motif played a not inconsiderable role. It is, in fact, a rather special chapter in the history of *ut pictura poesis* (which had better here be read *ut poesis pictura*) and like that doctrine has its *fons et origo* in classical antiquity. Historically, then, the motif has a twofold interest. On the one hand it is, as we have seen, a late manifestation, or, if one prefers, a delayed embellishment or grace

note in the long history of the mediaeval metaphor, nature is a book. But it is also very precisely a revival. For like other motifs in classical literature it was eagerly appropriated from long-revered Latin authors of the Augustan age by poets, including the most famous, of the Italian Renaissance, from whom it passed into the general literature and art of Europe. Shakespeare is a particularly interesting example. In *As You Like It*, as we have seen, he makes fun of "writing on trees," an already overworked topos in European pastoral literature. But this revival of a classical motif of sentimental content appears in the same play and in the same pastoral or mock-pastoral atmosphere, with traces of the mediaeval Christian tradition of nature as a book, offering edifying instruction. Shakespeare looked both ways; his nature speaks both languages. In his art memory of a grave tradition and the gay revival of a human motif from antiquity are felicitously and comically combined.

✇ 2. Antique Revival

It was surely a primitive instinct that, long before its recording in literature, impelled young men to write or carve the names of their mistresses on trees or inscribe them on walls. The motif, or a variant thereof, occurs in Greek literature as early as Aristophanes;[20] in the Hellenistic age it is found in the poetry of Callimachus[21] and in the eighteenth idyll of Theocritus,[22] where a plane tree is inscribed in honor of Helen on the occasion of her marriage to Menelaus. But it was in the richer and more sophisticated amatory context of Roman pastoral and elegiac poetry of the first century B.C. that Renaissance poets naturally found their inspiration to revive the topos, and it is significant for its later long history in pastoral literature—we have already encountered it in Shakespeare—that its first appearance in Latin poetry is in Virgil's *Eclogues*, most influential of all pastorals and a touchstone of Renaissance education. In the tenth Eclogue, Gallus, Virgil's poet-friend, pining with unrequited love, laments the absence of Lycoris, who has left him for another lover. "Well I know," he says, "that in the woods, amid wild beasts' dens it is better to suffer and carve my love on the young trees." And this will bestow a measure of immortality upon his passion, for as the trees grow, his love, recorded in their bark, will grow.[23] This conceit, reflected more than once in Renaissance poetry, was elaborated shortly after Virgil in the fifth Epistle of Ovid's *Heroides*. Here Oenone, the fountain nymph, deserted by Paris for Helen, recalls their earlier love when Paris was a shepherd—note the recurrence of the pastoral motif—and writes to him that "beeches still conserve my name which you carved on them, and I am read there OENONE written by your knife blade; and the more the trunks grow, the greater grows my name. Grow on, rise high and straight to make my honors known."[24] And it is not only her name that Paris has carved. For Oenone also prays that a poplar planted by the river Xanthus may live forever since Paris has written on its bark that if ever, having abandoned Oenone, he should continue to breathe, the waters of the stream will flow backward to their source; but since Paris now thrives without her, she bids them hasten to reverse their normal course.[25]

Paris carves Oenone's name, it may be worth noting, on the bark
of a beech, the smooth surface of which made it the favorite tree
for amatory inscription in the book of nature, though for the rhe-
torical expression of his vow never to abandon her, he uses the more
resistant and furrowed surface of the poplar. Finally among the
Augustan poets, Propertius, in a beautiful elegy which anticipates
Petrarch in sentiment, where nature in a lonely and silent place is
the only companion of his grief, declares in the agony of estrange-
ment from Cynthia that if trees understand love, beech and pine
shall be his witnesses, adding "How often do my words echo beneath
your tender shades, how often is Cynthia's name written upon your
bark."[26] The motif occurs occasionally in post-Augustan poetry,[27]
and then, to the best of my knowledge, it disappears for many cen-
turies. Flowing underground, as it were, like the fountain Arethusa,
it is reborn, appropriately on Italian soil, at the end of the fifteenth
century.

In a madrigal in the second book of his *Amori*, Matteo Maria
Boiardo, author of the *Orlando Innamorato*, addresses the *arbor
felice* on whose green bark he has inscribed the memories of his un-
happiness in love, begging it to press the moisture from its bark so
that it will efface (*smorzare*) the sweet verse in honor of his lady,
which, whenever he reads it, makes him weep.[28] In this late fifteenth-
century and perhaps first Renaissance example of amatory writing
on trees, Boiardo shows originality in reversing the sense of the an-
cient conceit that with the tree's growth the lady's name and praise
will grow, for here the poet implores the tree to obliterate the painful
testimony of his love. But not long after Boiardo's revival of the
topos, we find it treated in the normal classical manner in one of the
most famous examples of Renaissance pastoral, the *Arcadia* of Jacopo
Sannazaro,[29] "whom," as the humanist Fracastoro wrote, "even the
shade of Virgil applauded," no doubt because the *Arcadia* was steeped
in the *Eclogues* and ran the whole gamut of pastoral conventions.
The book contains several charming variations on the topos: one
shepherd recalling his forbears in Roman poetry simply writes on
the beeches in every wood so that there is not one that does not call
out "Amaranth";[30] another, recalling Boiardo and Propertius before
him, says that the trees constantly speak of his girl and show her

name written on their bark so that they constantly spur him to weeping and singing;[31] still another, surrounded by Petrarch's sympathetic world of nature, will find a *locus amoenus* where in his youth he wrote with his blade the name of the girl he loved before all his flocks, and "by now," he adds, following Virgil and Ovid, "the letters will have grown along with the trees; wherefore I pray the Gods that they preserve them always to her greater glory and eternal fame."[32] And in the Prologue to the *Arcadia*, a graceful apologia for the pastoral view of life, the author, speaking for himself, contrasts wild with disciplined nature (or, if one prefers, romantic with classical landscape), remarking that "the tall and spreading trees on shaggy mountains are wont to bring greater pleasure than are cultivated trees pruned and thinned by cunning hands in ornamental gardens." And it follows from this that "woodland songs carved on the rugged barks of beeches no less delight the one who reads them than do learned verses written on the smooth pages of gilded books,"[33] clear pastoral testimony that the natural pleasures of the country can equal those afforded by the arts of court and urban life and that poems written by shepherds in nature's book can easily vie with the verses of humanists.[34] Earlier, we have seen that the metaphorical book of nature which God himself wrote was an equal source of divinity with the actual books of scholars and theologians.

The various changes which Sannazaro rings on the theme "writing names on trees," pointing back as they do to Latin antiquity, and reminiscent as well of Petrarch's view of a nature in whose sympathetic voices the poet hears his own feelings echoed, offer a kind of paradigm of uses of the topos in later literature. Two famous Italian examples, destined to bear fruit in art as well as in literature and music occur in the sixteenth century, one near its beginning in Ariosto, the other in Tasso near its end. In these great poets, though its roots are deep in antiquity, the topos is treated, as it was to be in Shakespeare, with new freshness and color, becoming in the *Orlando Furioso* a significant part of an episode on which the central drama of Orlando's madness turns, in the *Gerusalemme Liberata* the closing motif in a pastoral interlude of extraordinary tenderness and lyrical beauty. The famous passage in Ariosto's poem is the chief concern of this essay.

❧ 3. Angelica

The *Orlando Furioso* is the literary masterpiece of the High Renaissance. First published in 1516, seven years after the completion of the Sistine Ceiling and three after Machiavelli wrote the *Prince*, it was revised and enlarged by Ariosto, receiving the form in which it is read today in 1532, the year before the poet's death. In form a meandering romance of arms and adventure with mediaeval and Renaissance forbears, its complex plot is nonetheless under sure artistic control. And its Renaissance character is further found in its richness of classical allusion and in the poet's wise and comprehensive overview of human nature pervaded by irony, serious and comic, which springs from his own experience and sophistication. In the large pageant of the *Orlando Furioso*, which mirrors the typical passions of mankind, love chiefly generates the action. The madness of Orlando, occurring at the exact mid-point of the poem, is caused by his obsessive and unswerving love for Angelica, Princess of Cathay, the most fascinating of Ariosto's women. Proud and beautiful, aloof and evasive, she disdains the love of the bravest knights, Christian and pagan, thinking, as Ariosto says, no man worthy of herself. Wandering in a forest in the early cantos, disappearing and reappearing among its lights and shadows, in a swift series of adventures she eludes one after another the lovers who seek to possess her. Thus she is an image of promise and frustration, of beauty ardently sought and unattainable. She is also in the poet's deeper view a symbol of the shifting character of experience, of the instability of all possessions, of the eternal mutability of life itself.[35]

Since Angelica in her early adventures is an image of the transitory and the unattainable, it might come as a surprise that this wandering and vanishing figure occupies in the pictorial illustration of the *Orlando Furioso* a predominant role assumed by no other character. But the reasons are not far to seek and they rest, as we shall see, on Ariosto's treatment of two strongly contrasting episodes. Angelica's precarious fortune at the poem's beginning was seldom illustrated;[36] it is suggested by the woodcut illustrating the first canto in the influential edition published by Gabriel Giolito de Fer-

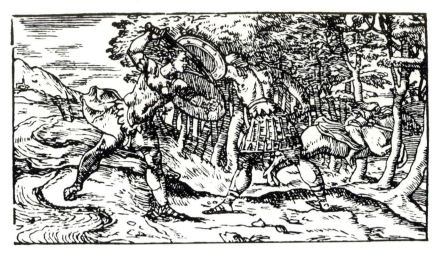

1. *Fight of Rinaldo and Ferraú*: woodcut for Canto 1 of the *Orlando Furioso*, Venice, 1542

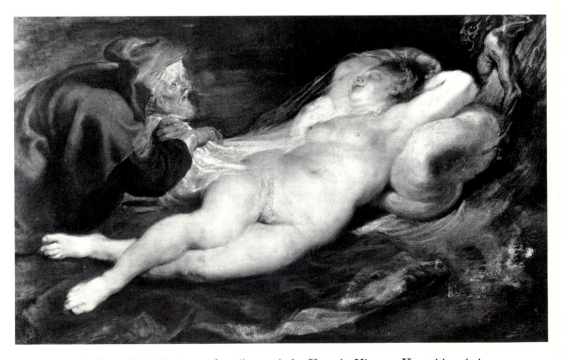

2. Peter Paul Rubens, *Angelica and the Hermit*. Vienna, Kunsthistorisches Museum

rari at Venice in 1542 (Fig. 1), the earliest to illustrate all forty-six cantos of the final text of 1532.[37] Here Angelica loses no time in escaping into the forest while two ardent admirers fight it out. But as the poem proceeds, we find her in worse trouble. Thus, after her escape from what looked like a close call with an aged hermit of doubtful morals whose baleful arts caused her to fall into an enchanted sleep—Rubens, probably remembering Titian's famous *Pardo Venus* in the Louvre, painted this moment, well suited to his robust genius, in a beautiful picture in Vienna (Fig. 2)[38]—she is shortly after in danger of her life when an evil people chain her to a rock to be devoured by the Orca, a ravenous sea-monster. From this appalling fate the paladin, Ruggiero, saves her, attacking from the air on the famous hippogriff, half horse, half griffin. Perseus, in Ovid's *Metamorphoses* IV, had similarly rescued Andromeda, flying, however, on footwings under his own power. But in a late mediaeval version in Latin of a *Moralized Ovid* which, as I have recently tried to show, Ariosto almost certainly knew, he saves her, riding a winged steed, Pegasus.[39] The dramatic scene of deliverance in the *Orlando Furioso* had considerable appeal to the painters from modest beginnings in a small north Italian furniture panel of the mid-sixteenth century (Fig. 3)[40] to the famous versions of Ingres in the first half of the nineteenth (Fig. 4),[41] and even into the twentieth, as in Odilon Redon's sinister picture in the Hahnloser Collection in Berne (Fig. 5),[42] where the monster has become a cruel and menacing symbol of evil.

But with the lovely Angelica black care always sits behind the rider. No sooner has Ruggiero delivered her than her maidenhood is endangered again when he flies her on the hippogriff's back to a remote grove (Fig. 6),[43] so moved by her beauty that he has fallen violently in love with her, forgetting entirely his true love Bradamante. But a magic ring, which Angelica places in her mouth, enables her to become invisible and to escape a badly frustrated Ruggiero. This comic episode was portrayed by Giovanni Bilivert in a painting in the Villa Medici at Petraia, in which we also see Ruggiero in a hurry to undress, while the hippogriff seizes the opportunity to take off on his own through the air (Fig. 7). Then Angelica wanders away alone again, a symbol of unstable fortune and of the elusiveness of things desired.[44]

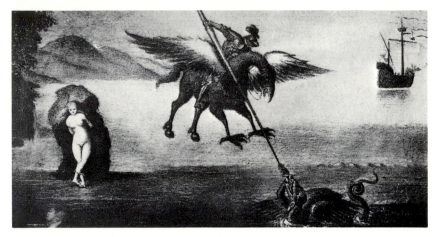

3. North Italian, mid-sixteenth century, *Ruggiero Delivers Angelica*.
Formerly Rome, Collection of Lionello Venturi

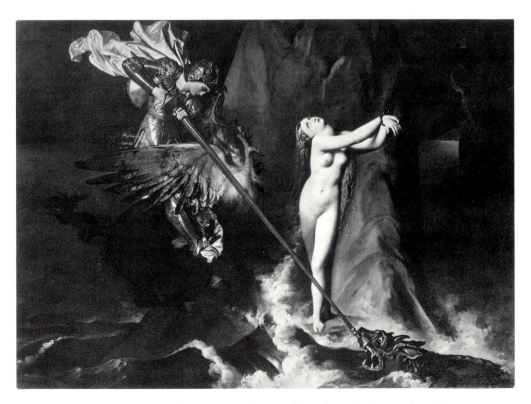

4. Jean Auguste Dominique Ingres, *Ruggiero Delivers Angelica*. Paris,
Louvre, 1819

5. Odilon Redon, *Ruggiero Delivers Angelica*. Berne, Hahnloser Collection

6. Charles-Nicolas Cochin *fils*, *Flight of Ruggiero and Angelica*: engraving for Canto x of the *Orlando Furioso*, Paris, 1775

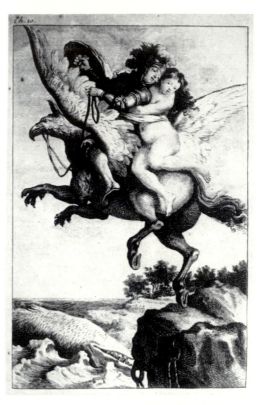

7. Giovanni Bilivert, *Ruggiero and Angelica*. Petraia, Villa Medici

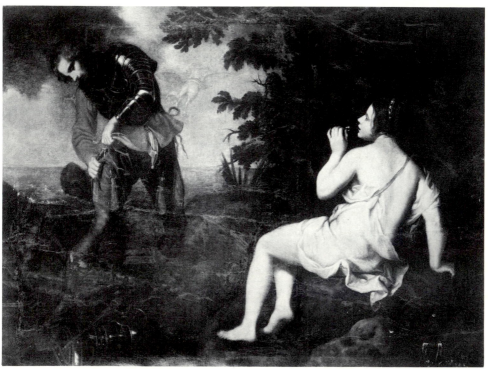

But Ariosto is a master of surprises, and not even the *varium et mutabile* of Angelica's restless nature and fortunes are exempt from change. Among the painter illustrators of the *Orlando Furioso*, the story of Ruggiero and Angelica is eclipsed in popularity by the famous pastoral interlude in the nineteenth canto where Angelica and Medoro, a most unlikely lover, carve their names on trees.[45] With a long classical and Renaissance tradition behind it and with enthusiasm for the pastoral continuing in Renaissance and later literature, it was a foregone conclusion that for three centuries Angelica's idyll would provide the painters with the Ariostan subject par excellence. It is worth noting that the tranquility of the pastoral episode, set in the peace of the country, is in sharp contrast to the rush and tumult of war in the cantos that immediately precede, as well as to the violent explosion of Orlando's madness that, at no great distance, follows. Thus the episode is an example of what Renato Poggioli called the pastoral oasis,[46] which can occur in epic or chivalric poetry, in romance or tragi-comedy, as an interlude or passing experience of unforeseen happiness and repose in a life of demanding action or exhausting emotion.

Near the middle of the poem we discover the proud lady in a forest near Paris close to the scene of a bloody battle between the Christian defenders under Charlemagne and the pagan army which seeks to invest the city. As she guides her palfrey through the forest glooms she comes by chance on a beautiful young Moor named Medoro who lies unconscious on the ground, his blood streaming from a grievous wound. Still full of proud disdain for her noble lovers— Ariosto emphatically reminds us of her *superbia* at precisely this point in his narrative—she has too long been guilty of intolerable hubris and the time for a radical change in her destiny has come. As she looks at the fair-haired youth of lowly lineage, the poor *fante*, Cupid, lying in wait, pierces her heart with an arrow. We see this decisive moment in the poem depicted in Giovanni Francesco Romanelli's picture in Denis Mahon's collection, a scene rarely illustrated in painting (Fig. 8). Closely following Ariosto's text it shows Angelica's discovery of Medoro and the flight of the fatal arrow shot by a cupid whose posture recalls that of Caravaggio's *Amor* in Berlin and its source in one of the *ignudi* of the Sistine Ceiling.[47] Medoro points to his dead king, Dardinello, while behind

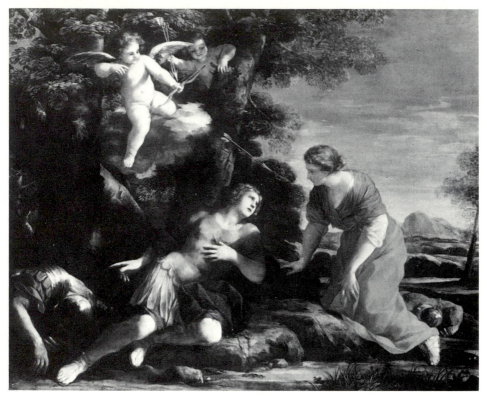

8. Giovanni Francesco Romanelli, *Angelica Discovers Medoro Wounded*. London, Collection of Denis Mahon

the kneeling Angelica lies the body of Cloridano, Medoro's faithful friend. With its clear references to Medoro's regard for his dead lord and Angelica's pity for the beautiful and sorely wounded young soldier, first stage of her developing love, the picture conveys well the feeling of Ariosto's narrative. Painted in the late 1630s, its elegiac sentiment and its landscape reaching back to Renaissance Venice may call to mind certain poetic mythologies and narrative pictures of the decade, notably of Nicolas Poussin, when Venetian painting was a strong influence in Rome.[48] The same moment is shown in another seventeenth-century picture, Matteo Rosselli's version in the Villa Medici at Petraia near Florence (Fig. 9). Here as Cupid shoots the ar-

row, Angelica, her hands clasped, kneels and bends over the wounded
Medoro, the two figures recalling their counterparts in religious
compositions of the Lamentation or Entombment. Also rare in
painting, though occasionally encountered in book illustration, is
the succeeding moment in the story, where Angelica, who had
learned the art of surgery from her mother in India, has gath-
ered a handful of medicinal herbs that grow conveniently nearby
and with their juice staunches Medoro's wounds.[49] Lanfranco's early

9. Matteo Rosselli, *Angelica and the Wounded Medoro*. Petraia, Villa
Medici

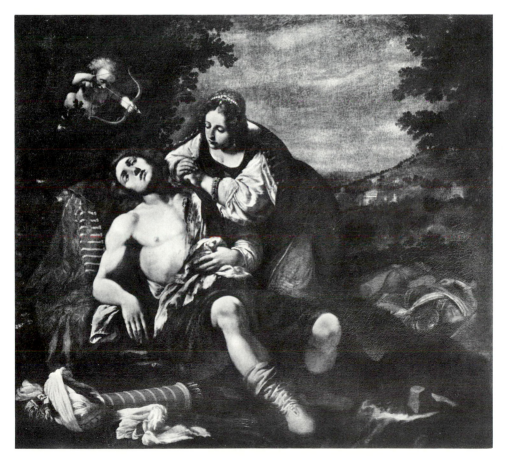

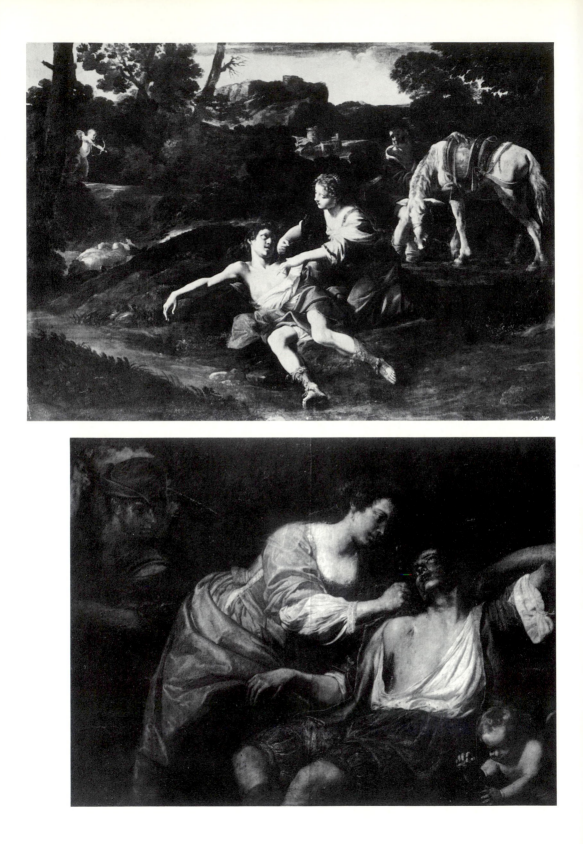

and romantic painting of about 1605 in the Palazzo Borghese at Anzio (Fig. 10) had already shown a diminutive cupid discharging the arrow, but concentrates on this later moment when, in a wild and somber landscape, a lovely and solicitous Angelica squeezes the juice into Medoro's wounds, while a shepherd, whom she had encountered in her search for the herbs, is seen behind with his sturdy horse.[50] A variant is found in a rather ponderous Genoese picture of about 1630 (Fig. 11)[51] where a symbolic cupid, by a charming pictorial license, does the laboratory job of pounding the juice from the herbs so that Angelica can give full attention to nursing.[52] The best known and one of the finest examples of the moment of healing belongs to the following century. It is a chef-d'oeuvre of Giambattista Tiepolo, one of four frescoes of 1757 in the Villa Valmarana at Vicenza devoted to Angelica's story (Fig. 12).[53] Here again in a traditional Lamentation or Entombment composition which the painter has adapted to an elegiac subject of similar basic content, Angelica, watched by the shepherd, supports and tends Medoro. Skillfully and compactly constructed to emphasize Medoro's mortal peril and Angelica's compassion—his pallid face with closed eyes is at the center of the great arc which swings through his body and carries to the horse's head—the fresco, like Lanfranco's picture, does expressive justice to the amatory and pathetic sentiment of Ariosto's narrative.

On the attendant's horse Medoro will shortly be carried to the shepherd's house to recover, a brief moment in the narrative which was not illustrated in painting until the nineteenth century and with distinction only once.[54] Delacroix's fine sketch in the Collection of Mr. and Mrs. W. Leicester Van Leer in New York (Fig. 13)[55] is true to the dramatic essentials in Ariosto's story: it shows an armor-clad figure leading a horse which carries a wounded man supported in his saddle by a woman walking by his side. But Delacroix with

Opposite top
10. Giovanni Lanfranco, *Angelica Tends Medoro's Wounds.* Anzio, Palazzo Borghese

Opposite bottom
11. Domenico Fiasella(?), *Angelica Tends Medoro's Wounds.* Genoa, Palazzo Rosso, depot

12. Giambattista Tiepolo, *Angelica Tends Medoro's Wounds*. Vicenza, Villa Valmarana

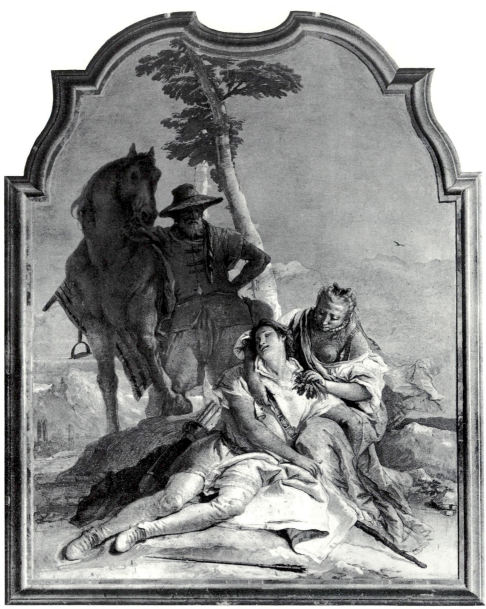

13. Eugène Delacroix, *Angelica Supports Medoro on the Horse*. New York, Collection of Mr. and Mrs. W. Leicester Van Leer

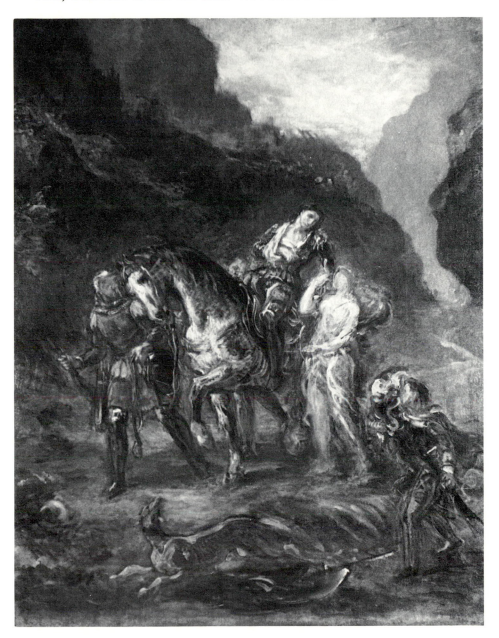

full pictorial license has changed Ariosto's shepherd who leads the horse into a martial page, has added another page and a dog for good compositional measure, and has deprived Angelica of her palfrey so that she goes on foot. Further, being a nineteenth-century romantic, he has set the scene in a gloomy and savage mountain gorge, a "deep romantic chasm" to recall Coleridge's phrase, for which he had only a bare hint from Ariosto, who merely says that the shepherd's house to which they are proceeding was set "nel bosco infra due monti." But having taken such liberties as he pleased with the letter of Ariosto's text in the interest of his own art, he is still true to its spirit, and with the intuition of genius has left us a splendid sketch in which the chivalry, charity, and adventurous atmosphere of the poem's episode are eloquently transformed into a wonderfully expressive visual counterpart. Delacroix was one of the last and the most distinguished exponent among the great painters of the pictorial interpretation of major literature. This was because he was one of the last great artists with a broad literary education. Well versed in the poets of antiquity and the Renaissance, he had, like Voltaire and Goethe, profound admiration for Ariosto as one of the greatest of poets.[56] Being a painter of genius as well, Delacroix was ideally gifted for casting the content of poetry into a vivid pictorial equivalent.

It should also be observed that Delacroix's *Angelica and Medoro* was painted within the span of years when the painter displayed a particular sensitiveness to New Testament and other themes of compassionate content, notably the theme of the Good Samaritan, in which in the version of 1850 the wounded man is lifted with care and placed on a horse's back in a wild romantic setting (Fig. 14). In iconographic detail, in landscape, and in a depth of sentiment that recalls Rembrandt, this painting is a close counterpart to the *Angelica and Medoro*, and Delacroix in his deviation from Ariosto's text may have been influenced by some earlier portrayal of the Good Samaritan,[57] perhaps even by his own. Thus in his case, as when Tiepolo painted Angelica caring for Medoro's wounds, earlier religious iconography served as a model for a modern theme of like elegiac content, and an older language of form maintains its eloquent continuity.

14. Eugène Delacroix, *The Good Samaritan*. Private Collection

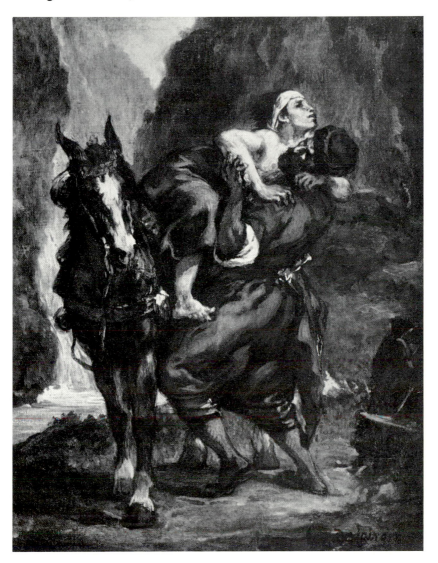

4. *Locus amoenus*

We have followed Angelica's history in broad outline to the point where she and Medoro repair to the "assai buona e bella stanza" of the shepherd. There in a pastoral setting—we have now returned to the main track of the argument—she cares for his wound, while her own wound from Cupid's arrow grows larger and more painful. At length restored to health, Medoro reciprocates Angelica's love, and the result, to make their love honorable, as Ariosto says, is a marriage which they celebrate with holy ceremonies, having Love as the best man and the shepherd's ancient wife as bridesmaid. But Angelica now deeply in love has suffered a sea-change. No longer proud and elusive, no longer unattainable, she ceases to be a fascinating symbol of promise and frustration, and of the illusory character of experience. With her love settled on Medoro, her characteristic, autonomous life vanishes and her generative force in the poem's action is finished. Henceforth, apart from two minor appearances, she passes from the spacious stage of the *Orlando Furioso*, retiring with Medoro to Cathay where she makes him her king.[58] But the comic irony of the proud princess' headlong capitulation to the charms of the poor infantryman, after scorning the courtship of the highborn paragons of chivalry, delighted all of Europe; it provided Ariosto with a delicious pastoral intermezzo, which is also a preparation for Orlando's madness,[59] and in due course the painters and engravers with a pastoral and amorous subject which outdid all others from the *Orlando Furioso* in popularity.

Angelica and Medoro have more than a month's honeymoon in their *locus amoenus* in the country, the indispensable setting in pastoral literature for the joys of free and true love, away from the inhibiting and artificial conventions of courts and cities. It is also bucolically *de rigueur* that as they wander about the green meadows or rest in the shelter of a propitious cave during the heat of midday —here Ariosto remembers two famous lovers of antiquity, Dido and Aeneas, who found refuge in a cave from a storm[60]—they should always have ready at hand the means for recording their love in nature's book. In Ariosto's words: "Among so many pleasures, when-

ever a straight tree was seen shading a fountain or clear stream, she had a pin or knife ready at once; likewise if there was any rock not too hard; and outdoors in a thousand places and likewise as many times on a wall in the house, ANGELICA AND MEDORO was written, bound together with various knots in different ways."[61] This is the famous stanza which suggested manifold variations on a theme to the artists of four centuries.

It is, as we have seen, a very old theme. But it is important to note that Ariosto's version of carving names on trees, while it continues a classical tradition, is original both in detail and sentiment. For where, as we observed, in Virgil, Ovid or Propertius, or again in Ariosto's Italian predecessors, Boiardo and Sannazaro,[62] trees are carved by forsaken or despondent swains who lament the absence, loss or indifference of a mistress, or where carving on trees may console the writer or may honor and commemorate a happy or unhappy love that is past, where in any case the lover nearly always inscribes alone in the solitude of the forest, in the *Orlando Furioso* by contrast the elegiac note is entirely absent. Here carving on trees with both lovers present is no longer an expression of sorrow, loneliness or nostalgia, but, as the visual arts were soon emphatically to testify, of intense, unalloyed, present happiness. Thus the episode of Angelica and Medoro had everything in its favor: a long tradition behind it of pastoral setting and imagery, an arresting yet half-comical reversal of fortune wrought by the invincible power of love, and the poet's own brilliant gift of pouring very old wine into very attractive new bottles.

The motif of carving names on trees did not, we should observe, occur first in art as illustration of the *Orlando Furioso*. It had appeared in an edition of Ovid's *Heroides* published in Paris shortly after 1500 by the famous printer Antoine Vérard, about a dozen years before Ariosto's poem came off the press.[63] A miniature at the beginning of the fifth Epistle depicting Paris about to carve the name of the nymph Oenone on a beech (Fig. 15) illustrates the passage we have earlier discussed.[64] The mediaeval tradition of representing figures from ancient history and poetry in contemporary costume is still present here. But although the style is archaic by Italian Renaissance standards of 1500, the miniature has special interest as the first illustration of the motif in a Latin author who was

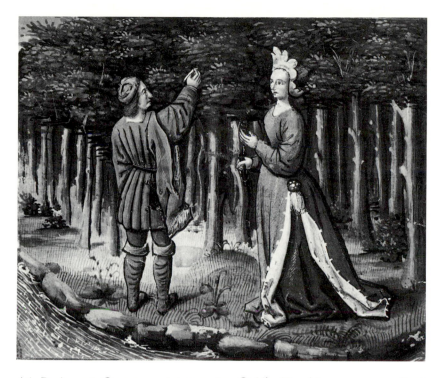

15. *Paris and Oenone*: miniature for Ovid's *Heroides*, ca. 1500. Paris, Bibliothèque Nationale

a chief source for its use in new contexts in Renaissance and later literature and through this literature in post-Renaissance and Baroque painting. Some four decades later, in 1539 or 1540, the German artist, Georg Pencz, probably during a sojourn in Italy, depicted the same subject in an engraving of deeply modeled forms, but Oenone, who deserved something better, has fared badly, all her live emotion being reduced to a ponderous inertia (Fig. 16).[65] Examples like these which had no direct influence are wayward voices, so to speak, announcing the plastic availability of a motif that Virgil, Ovid, and other poets, ancient and modern, had been calling to men's attention. And it is interesting that Paris and Oenone, a theme from antiquity, continued until the eighteenth century to be popular in Dutch art,[66] while in classical Italy and also in France, Ariosto's popu-

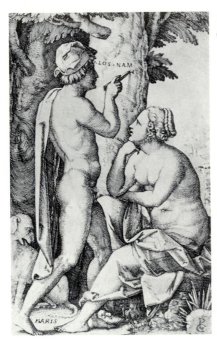

16. Georg Pencz, *Paris and Oenone*: engraving, 1539-1540

17. *Angelica and Medoro*: woodcut for Canto XIX of the *Orlando Furioso*, Venice, 1577

lar modern subject of Angelica and Medoro crowded out the Ovidian prototype, which appears hardly at all.

It was not until nearly forty years after Pencz's engraving that the Ariostan version of Names on Trees received the honor of a small woodcut in an edition of the *Orlando Furioso* published in Venice in 1577 (Fig. 17).[67] Its appearance at this moment—the identical cut was repeated in several later editions—may reflect a renewed interest in the pastoral generated by Tasso's *Aminta* (first performed at the court of Ferrara in 1573) and further stimulated by the tender episode of Erminia among the shepherds in his *Gerusalemme Liberata*. This was not published entire until 1581, but a first draft finished six years earlier was read by Tasso's learned friends and a number of revisers who surely circulated word of it to others. In both pastoral drama and epic poem there is amatory writing on trees, and Erminia carving the name of her idol Tancred was to appear occasionally in

seventeenth-century art, as in Salvator Rosa's spacious landscape at Modena, where we see her with her flocks nearby in the chequered shade carving the name of Tancred on a magnificent tree, while at the right shepherds enjoy the pastoral repose and a far view extends over the bucolic Eden (Fig. 18). In any case the 1577 woodcut shows Angelica and Medoro seated side by side, hand in hand, in a woodland setting by a fountain, as Ariosto describes them, while Medoro carves names or encomia on a tree trunk as she looks on admiringly.[68] The undecipherable character of the inscription may be meant to suggest Medoro's native Arabic, which he naturally used for this intimate woodland self-expression.[69]

18. Salvator Rosa, *Erminia Carves Tancred's Name on a Tree*. Modena, Galleria Estense

The scene flourished in the history of art; in fact it comes near rivaling in fecundity such popular Ovidian mythologies of amorous content as Venus and Adonis, Diana and Endymion, and others, and it far outstrides its Ovidian forbear, Paris and Oenone, and its follower, the Erminia scene from Tasso. In terms of artistic quality it inspired a few first rate works, and these as often drawings as paintings. A particular artistic style may be hospitable or inhospitable to the quality of Ariosto's poetry. When the pictorial vehicle is the con-

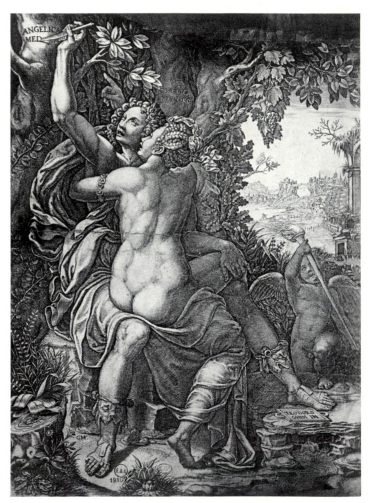

19. Giorgio Ghisi after Teodoro Ghisi, *Angelica and Medoro*: engraving, before 1582

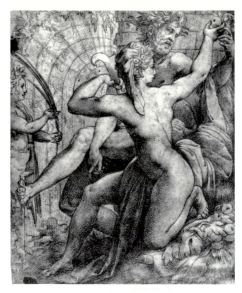

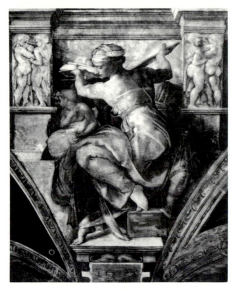

20. Perino del Vaga, *Vertumnus and Pomona*: drawing. London, British Museum

21. Michelangelo, *Libyan Sibyl*. Vatican, Sistine Chapel

trived ingenuity and cool abstractness of the Mannerist style of the middle and late sixteenth century, the picture itself may be ingenious or interesting, but the uncomplicated freshness and charm of Ariosto's narrative may fare badly. For example, in an eclectic and influential engraving before 1582 by the Mantuan Giorgio Ghisi, working in the figure style of central Italian Mannerism,[70] there is disharmony between the expression of amorous content and artificial ingenuities of figure style (Fig. 19). Angelica, her knotty torso cast in a schematic idiom of ostentatious and unfeminine muscularity, sits precariously on Medoro's right thigh, slinging her left leg over his left as he reaches up to carve the immortal names.[71] In a complicated group like this it is sometimes difficult to work out the counterpoint of arms and legs. The group harks back to the contrived poses in drawings of the Loves of the Gods of 1527 by Raphael's follower Perino del Vaga, which were engraved soon after by Jacopo Caraglio. Perino's drawing in the British Museum of *Vertumnus and Pomona* (Fig. 20) was obviously the source of Ghisi's engraving.[72] In both artists, arms and legs seem to thrust out from the center like the spokes of a wheel. Both female figures derive clearly from Michelangelo's Libyan Sibyl (Fig. 21), and behind the exaggerated muscularity and ex-

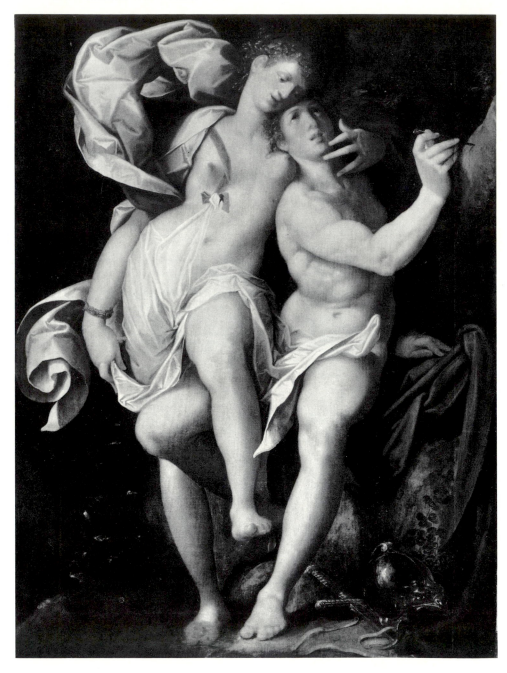

22. Bartolomäus Spranger, *Angelica and Medoro*. Munich, Alte Pinacothek

travagant counterpoise, lies the influential canon of Michelangelo's heroic anatomy and powerful movement, used by the master for magnificently expressive purpose and altered here to serve a mere ingenious aesthetic which, divorced from the normal canons of form and movement, has become its own artificial excuse for being.[73] This criticism, however, may appear too severe if one compares Ghisi's engraving with Bartholomaeus Spranger's grotesque and grossly unpoetical extravaganza at Munich of about the same date (Fig. 22), painted a few years after his long exposure to many forms of Italian Mannerism. Never did Vasari's wholly Mannerist dictum of painting first to show one's skill in art and only secondly to follow the story wreak greater havoc with the high poetical quality of a literary text.[74]

In the last decade of the sixteenth century the first extant painting of *Angelica and Medoro* was executed by Carletto Caliari, son of Paolo Veronese (Fig. 23).[75] It recalls Ghisi's engraving in its gen-

23. Carletto Caliari, *Angelica and Medoro*. Padua, Barbieri Collection

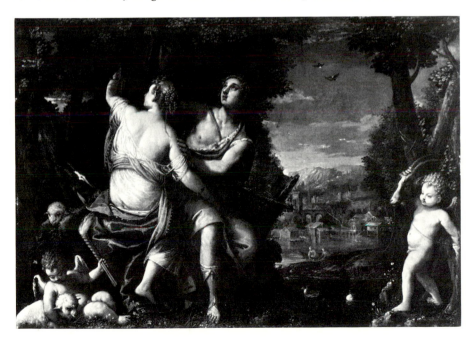

eral composition of Venetian type; the obvious Mannerist canon seen
in the repetitive yet contrasted poses of the lovers also recalls the
engraving, but Carletto's group is more scholastically schematic.
The attractive landscape, with its wings of deep green foliage and a
view between over shining water, its light reflected on houses and
mills, to a rolling upland and distant mountains, recalls Domenico
Campagnola. The delightfully observed details of flowers, ducks
and sheep, perhaps suggesting the stimulus of northern painting,[76]
endow the picture with a freshness and country atmosphere appro-
priate to Ariosto's pastoral, on which the conventional figure rhetoric
does not seriously intrude. According to his seventeenth-century bi-
ographer, Carlo Ridolfi, a genuine feeling for nature led the young
painter to delight in drawing "i pastori, le pecore, l'herbette, i fiori e
ogni villesco stromento."[77] We may also note that in this picture, as
in Ghisi's engraving, Cupid holds a burning torch signifying that the
passion of Angelica and Medoro prospers in full blaze.[78]

At the beginning of the seventeenth century an interesting ver-
sion of Names on Trees occurs in France in a painting in the Louvre
by an artist of the second school of Fontainebleau.[79] In this arresting
composition in the Mannerist style (Fig. 24), Angelica and Medoro
occupy the full picture space to the right; they are seated on a rock
in a complicated pattern in which the thrust of torsos, arms, and legs
again forms a series of contrasts and balances; he is intent on carving
her name on a tree stump while she as intently looks on. Both fig-
ures, but most notably Angelica, have their direct ancestry in Michel-
angelo's *ignudi* (Fig. 25) and are juxtaposed in a manner that shows
how fertile a field for the Mannerist artist, how suggestive of com-
plicated invention, these Sistine *ignudi* could be.[80] Striking in de-
sign and in powerful color contrasts, it is a joyless picture, observing
merely the letter but not the spirit of Ariosto. Its inner life is a
strange melancholy, a cool malaise which might at long range recall
the mid-sixteenth-century portraits of an Angelo Bronzino and has
nothing to do with the felicity of love in idleness enjoyed by Ari-
osto's lovers. Here again the canons of style of a special moment in
the history of art are exigent enough to throw up an artificial bar-
rier between the simplicity of the poet's pristine narrative and its
true interpretation by the sister art of painting.

Although the number of paintings it inspired during the first cen-

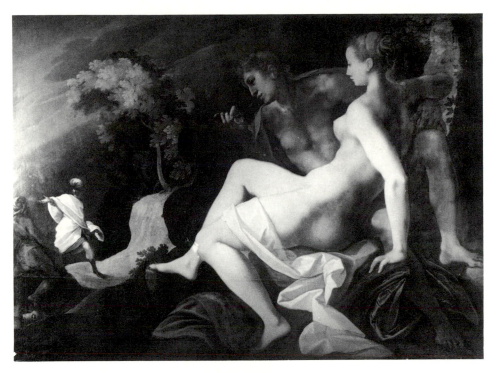

24. Circle of Toussaint Dubreuil,
Angelica and Medoro. Paris, Louvre

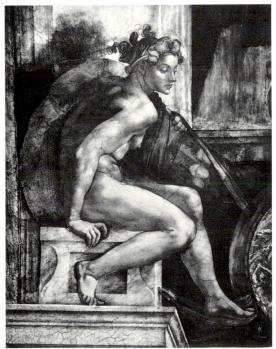

25. Michelangelo, *Ignudo*. Vatican,
Sistine Chapel

tury of its life were few, the *Orlando Furioso* was enormously popu-
lar in the sixteenth century and into the seventeenth. In Italy it ap-
peared in over one hundred and fifty-four editions in the sixteenth
century alone, more than half of these illustrated by woodcuts or
engravings at the beginning of each canto,[81] and various episodes in
the poem were imitated or continued by writers now largely for-
gotten, but including the illustrious name of Pietro Aretino. Mean-
while, and notably after the publication of Tasso's *Gerusalemme
Liberata* in 1581, the poem had its severe critics and these continued
into the next century. Nourished on Aristotle's *Poetics* and its Italian
commentators, and shadowed by the moralizing temper of the Coun-
ter Reformation, such critics took issue with what they saw as the
poem's lack of formal unity, decorum, and at times, decency. The
Orlando Furioso, they decreed, deserved no higher status than that
of a romance; it was not a true epic that could hold its own, as
Tasso's rival poem might claim to do, with the noblest epics of an-
tiquity.[82] In France the poem had its adverse critics as well, but it
was admired at court and in the salons, and was several times trans-
lated. Most important, it captivated the poets, and it was a liberating
influence on the Pléiade, for Ariosto's richly varied treatment of the
passion of love, which included robust sensuality, provided invigor-
ating relief from Platonic metaphysic and Petrarchan abstraction.[83]
In Ronsard there are clear echoes of the idyll of Angelica and Me-
doro, and Angelica in general has a marked appeal to the imagina-
tion of the poets. One pays his mistress the ultimate compliment of
proclaiming her beauty superior even to Angelica's. Another sees
Angelica as an example of indocility and independence, of *l'humeur
libre*: governed only by whims, she is cruel as well as beautiful.
Others, distraught at the coyness of their mistresses, clutch at the
happy example of Medoro, hoping that their modern Angelicas
will be as kind.[84] As for inscriptions on trees, there are many in
French sixteenth-century poetry and they are predominately elegiac
in character.[85] It must suffice here to remark that Du Bellay in this
vein, anticipating Tasso, counsels the wanderer in a winter landscape
to read his mournful epitaph engraved on the furrowed bark of a
tree,[86] and in a graceful poem of thanksgiving to Venus he dedicates
and inscribes a myrtle in her honor.[87] It is in the seventeenth rather
than the sixteenth century that we encounter in French literature

references to the actual names of lovers, or more generally their interlocked initials (*chiffres*), carved on trees.[88] This is the case for instance in a number of passages in Honoré d'Urfé's long pastoral romance, *L'Astrée*, which are generally elegiac in tone, and reminiscent of the tradition extending from Virgil and Ovid to Sannazaro and Tasso.[89] But this tendency to make the expression of love more personal may also be considered a symptom of the greater closeness to reality that marks the spiritual climate and artistic expression of the seventeenth century.

26. Guercino, *Angelica and Medoro*: drawing. London, British Museum

✥ 5. Baroque

During this century, the Baroque century, the Mannerist deadlock, as a perceptive critic has called it, with its often abstract and sometimes uncreative formulas, was broken by painters on both sides of the Alps whose essential instinct was to observe nature again with fresh vision.[90] And it was inevitable that the pictorial interpretation of Ariosto would thrive on this change. Guercino of Cento near Bologna was a notable illustrator of Ariosto, as he was of Tasso. In 1617 at the Villa Giovannina near Cento he executed, probably with assistants, a series of frescoes depicting scenes from the *Orlando Furioso*, seven illustrating the story of Angelica.[91] The frescoes are heavily repainted; one represents Angelica seated on a rock or tree stump near a stream and reaching up to carve the names on the bark of a large tree, while Medoro bends over her. This is the first portrayal of the subject to show Angelica rather than Medoro carving. The text of the poem could indicate that either or both did the carving, although it was Angelica who carried the tool kit (XIX, stanzas 35-36). A quarter of a century later Guercino painted two large canvases of the subject that have disappeared, both recorded in his *Libro dei Conti*. Three drawings have survived. The earliest of these, a pen drawing in the British Museum (Fig. 26), may be dated about 1621. In this wonderfully spacious landscape, flooded with light, in the great peace of midday, Angelica and Medoro have been busily at work. She turns to look as he points to a new inscription, while a tutelary cupid watches from above and all nature reflecting the warmth of their emotion seems to explode, notably in the center, and the trees to rise as if impelled by a vital force.[92] The landscape is also founded in reality—the forms of the trees recall the country east of Bologna where Guercino was born and lived much of his life. Some twenty years later, when the spirit of classicism had grown upon him, he made two fine drawings in pen and wash, which are carefully balanced in composition and without the energetic naturalism of the landscape. One, in the collection of Denis Mahon in London, may be a study for the large picture of 1647. Here the figures, seated in the foreground plane as in a frieze, are in almost

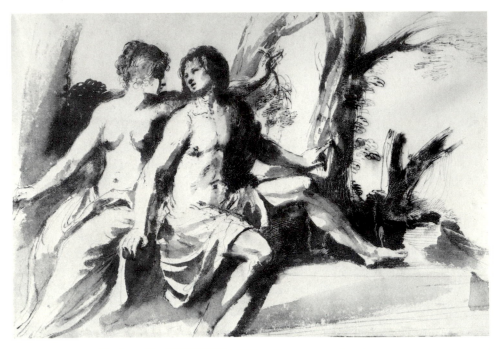

27. Guercino, *Angelica and Medoro*: drawing. London, Collection of Denis Mahon

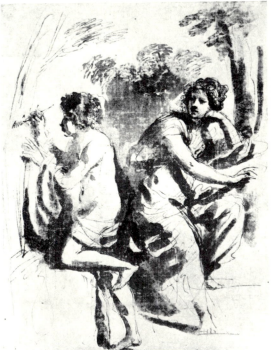

28. Guercino, *Angelica and Medoro*: drawing. Present whereabouts unknown

paradigmatic balance (Fig. 27). The other, which appears similar in style, shows Medoro and Angelica, again in compositional equilibrium, but also in formal contrast. He carves her name at the left, his body vertical like a column, while she is seated at the right, her body swinging away from him in active counterpoise as she turns her head to watch him carve (Fig. 28).[93] The composition of this drawing, with the opposition of vertical accents left and a figure in counterpoise right anticipates that of Guercino's Cumaean Sibyl in Mr. Mahon's own collection, while the figure of Angelica recalls a number of his Sibyls painted during the 1650s.[94]

A scant handful of portrayals of the subject by other seventeenth-century Italian painters have survived. One of them, in the collection of the Duke of Buccleugh at Boughton House, Northamptonshire (Fig. 29), which is, I believe, unpublished, has carried an old

29. Central Italian, mid-seventeenth century, *Angelica and Medoro*. Northamptonshire, Boughton House, Collection of the Duke of Buccleugh

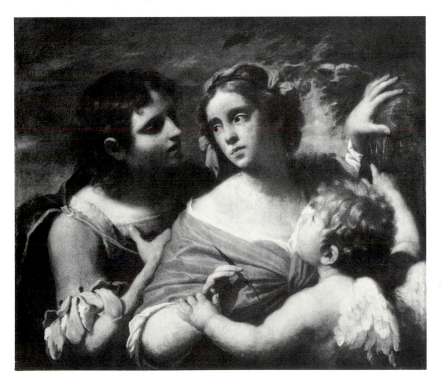

attribution to the Bolognese, Alessandro Tiarini, surely wide of the mark.[95] Various verbal suggestions of authorship have been made, which agree only in a presumptive date of about the mid-century and in a central Italian locale.[96] In this painting of tender sentiment, Angelica has carved the names, and their amorous import is expressed not only in the glances of the lovers but in the gesture of an enchanting, curly-haired *putto*, who is, perhaps redundantly, calling Medoro's attention to Angelica's name.

A warm Venetian interpretation of the subject which is not far in date from the Buccleugh picture is Pietro Liberi's beautiful painting in the gallery at Schleissheim in Bavaria (Fig. 30), which testifies to his immersion after 1643 in the Venetian milieu, and to his profound admiration for Titian and other great Venetians.[97] Angelica is seated, while Medoro reclines close beside her, pointing to her name written on a tree; their intimacy of posture and feeling recall

30. Pietro Liberi, *Angelica and Medoro*. Schleissheim, Bavaria, Gallery

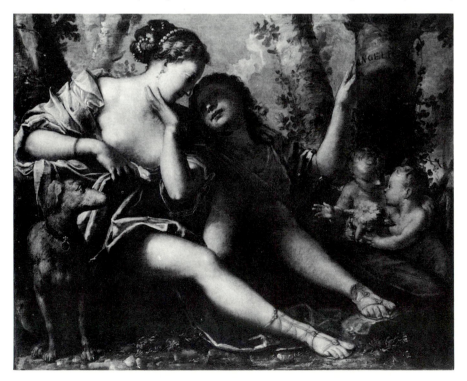

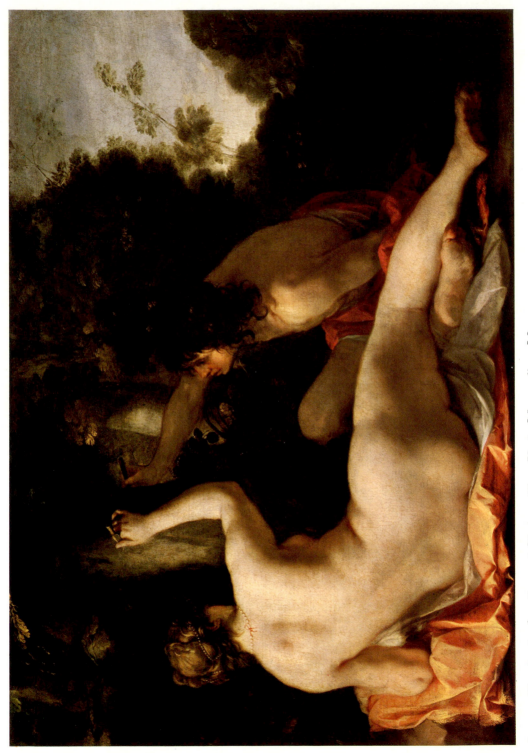

Jacques Blanchard, *Angelica and Medoro*. New York, Metropolitan Museum

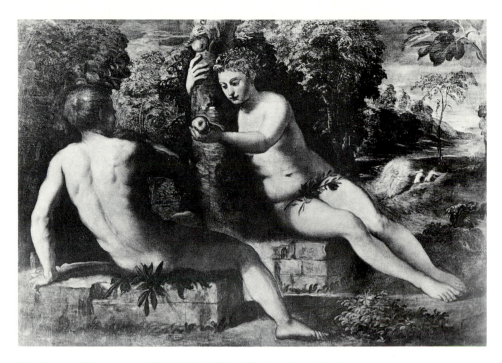

31. Jacopo Tintoretto, *The Fall of Man*. Venice, Accademia

similar groups of lovers in Titian's pastorals, in the *Three Ages of Man* in Edinburgh and the *Nymph and Shepherd* in Vienna.[98] The diagonal arrangement of the figures, which here fill the picture space to the left, recalls a common compositional practice of Tintoretto (Fig. 31) that recurs in other versions of *Angelica and Medoro* (cf. Color Plate, opposite, and Fig. 44).

In France, reflecting the high esteem in which the *Orlando Furioso* continued to be held, a few artists are recorded as depicting the subject. The finest painting is Jacques Blanchard's handsome canvas in the Metropolitan Museum (opposite). This Parisian artist had fortunately spent two years in Venice attracted by masterpieces of the Venetian Renaissance, and the picture, painted in the late 1620s, is clearly influenced, as Anthony Blunt observed,[99] by Paolo Veronese's clear colors and silvery light, as it is by the same compositional formula of Tintoretto (Fig. 31), which we have just observed in Pietro Liberi. In Blanchard's picture we have the engaging prospect

32. Giorgione, *Fête Champêtre*. Paris, Louvre

—rare in portrayals of the scene—of both lovers in a rich woodland
setting intent on the commemoration of their love. The new naiveté
of the once sophisticated Angelica, the total absorption of both in
their pastoral play, the brief hour of their untrammeled rural hap-
piness—in short the mood and quality of Ariosto's poetry—have
here been well interpreted.[100] And behind this picture by a French
painter lies again the long tradition of pastoralism not only in litera-
ture, but in Venetian painting reaching back to Giorgione (Fig. 32)
and early Titian with its disclaimer of active life in favor of amatory
discourse or dreaming, or mere relaxation, in a landscape natural or

cultivated, but always attractive. Venice had long fostered idling in the country and often to the finest pictorial effect.

Not long after Blanchard's Italian sojourn, Nicolas Poussin, active in Rome, was himself to be deeply influenced during the late 1620s and early 1630s by Venetian painting.[101] He was once thought to have depicted Angelica and Medoro in a beautiful early drawing of ca. 1626-27 in the National Museum in Stockholm (Fig. 33).[102] Executed with pen and delicately applied bistre washes over red chalk, this is a true *poesia*, tranquil and idyllic in mood, and reveal-

33. Nicolas Poussin, *Paris and Oenone*: drawing. Stockholm, National Museum

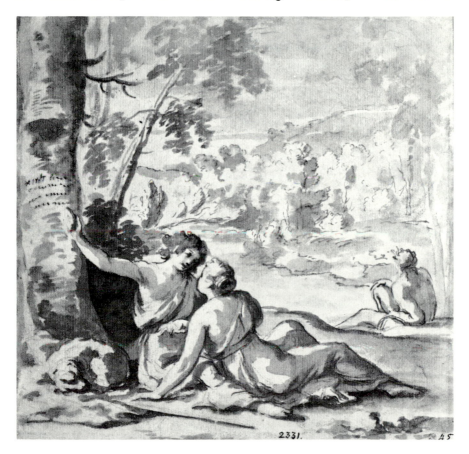

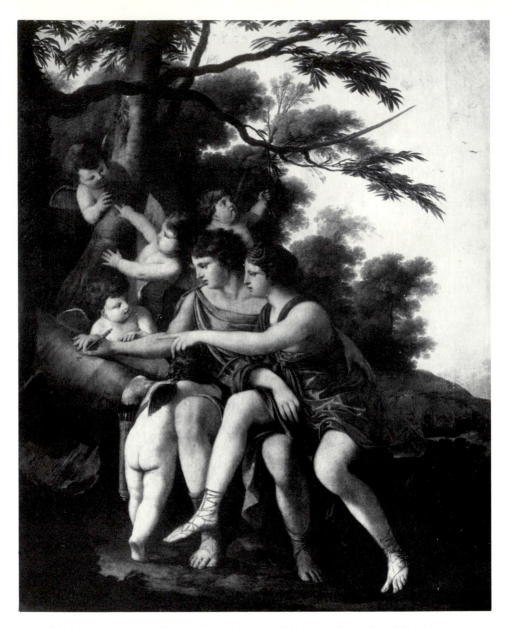

34. Laurent de la Hyre, *Angelica and Medoro*. Marseille, Musée des Beaux-Arts

ing Poussin's study of the beautiful effects of light—those "beaux accidents de lumières"—which his biographer André Félibien tells us he sought in his solitary walks in and near Rome. But the draw-

ing can no longer be called *Angelica and Medoro*. Its proper title,
indicated by the presence of the river god, is *Paris and Oenone* and
it is a rare example of this Ovidian theme by a French or Italian
artist. The writing on the tree must refer to Paris' vow to Oenone,
before he abandoned her for Helen, that if he ever ceased to love
her the waters of the river Xanthus (near which the inscribed poplar
grew) would flow backward to their source. Unhappily he deserted
Oenone and the Xanthus still headed downward to the sea, unmind-
ful of the perjured vow.

More than a decade after Poussin's drawing, Laurent de la Hyre
executed a painting, now in Marseille, which showed Angelica and
Medoro seated side by side on a fallen tree trunk, on which he has
begun to carve her name (Fig. 34). Her right leg is slung affec-
tionately over his left, recalling a motif popularized, as we have
seen, by Jacopo Caraglio's engravings after Perino del Vaga of more
than a century earlier (Fig. 35). The painting, with the classical
profiles of the lovers, the character of the foliage, and the playful
putti in the trees (two of them pointing out the names inscribed on
another tree trunk) all indicate the painter's association with Pous-
sin's art of the 1630s, though here the mood is cool, and the lovers,
carefully posed, are going about their work with a well-rehearsed,
almost rational precision.[103]

35. Jacopo Caraglio, *Neptune and
Doris*: engraving

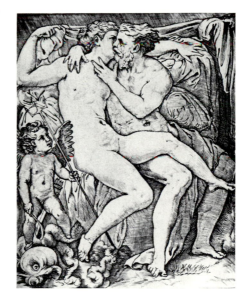

✥ 6. Rococo

The *Orlando Furioso* suffered a decline in critical regard in the later seventeenth century in France. Critics of strong Aristotelian persuasion who approved the dramatic unities of a Racine or, despite reservations, preferred the epic framework and serious intent of the *Gerusalemme Liberata,* looked askance, as they had earlier in Italy, at the seemingly rambling, unclassical form of the *Orlando Furioso.* A Boileau or a Père Rapin could take exception in Ariosto's poem to what they saw as the haphazard composition of the romances, as well as to certain passages of easy morality—Madame de Sévigné called them "endroits facheux"—but, despite classical or moral bias, such critics were also aware that an exceptional poet had written a work of distinction and grace.[104] Choice spirits like Racine, whose letters are sown with quotations from the *Orlando Furioso,* and Madame de Sévigné, herself, read it with obvious delight. The *Orlando Furioso* led her at times to indulge a romantic imagination, and contrary to the theorists, she found Ariosto's rapid changes of scene and event a narrative virtue; and although she thought Tasso more decorous reading for a young girl, she remembers with pleasure Medoro's inscription wishing peace and happiness to the cave which had sheltered his hours of love with Angelica.[105]

The eighteenth century at length saw the *Orlando Furioso* returned to full critical favor in high places. Early in the century the Abbé Dubos, an independent spirit, respected the historical role of the rules of classicism without endorsing their infallibility. He was well aware that the unity of action in Ariosto was conspicuous by its absence ("Homer was a geometrician compared to him"), also that Ariosto's decency, which he merely says he will not speak of, left something to be desired; still he preferred him as a true poet to Tasso.[106] The Président de Brosses, writing from Italy, is wholly enthusiastic, acclaiming the poem's grace, facility and range of tone.[107] Voltaire, after earlier censure,[108] in 1742 revises his opinion: the poem is no epic, but it is a work of genius and charm.[109] As he grew older, Voltaire warmed to this view, stimulated at one point by conversations with Saverio Bettinelli,[110] prominent among Italian de-

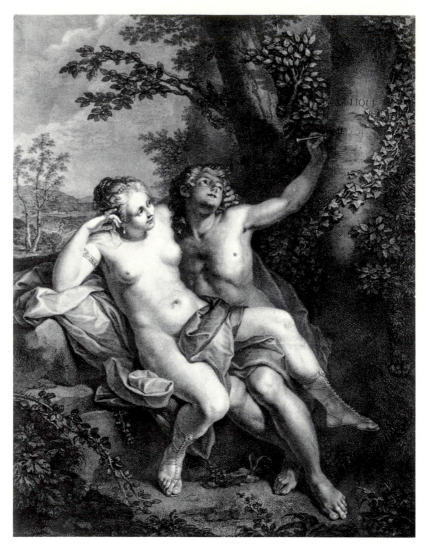

36. Jean Raoux, *Angelica and Medoro*: engraving by Nicolas de Launay

fenders of the poet, so that in 1775 he could write that Ariosto "est mon homme, et plutôt un Dieu,"[111] surely, as a modern critic has wittily remarked, the only god Voltaire ever recognized.[112] Still later, he declares Ariosto the first poet of Italy and perhaps of the whole world,[113] and at last in the *Dictionnaire Philosophique* he finds the

poet sublime as well as delightful, and humbly apologizes for not including him among epic poets.[114] Voltaire's significant shift from his early classical position to an appreciation of Ariosto's poetical genius *per se* (an appreciation warmly shared by Goethe)[115] was a signal for the high popularity of the *Orlando Furioso* among readers and critics during the oncoming romantic revival. Their fervid admiration was due to follow in any case from the wide extension of literary horizons beyond Greece and Rome to include again, among much else, the chivalric literature of the Middle Ages, and from an urgent concern with the expression of individual genius, for which no rules based on antiquity and the Renaissance could supply a pattern.

The eighteenth-century taste in France for gallant subject matter occasionally found a congenial theme in Angelica and Medoro. The present locale of Jean Raoux's painting of the early years of the century is unknown to me, but its likeness is preserved in an engraving executed much later by Nicolas de Launay (Fig. 36).[116] Both the composition and the erotic frankness, tempered here by elegance, recall the two years passed in Venice by the young painter after he had won the Grand Prix of the Academy in 1704 (one may detect, perhaps, an afterglow of Paolo Veronese),[117] while his revival of the old Mannerist motif of the slung leg, reaching back as we have seen, to Perino del Vaga two centuries before (cf. Fig. 35), may reflect his sojourn in Rome during the same Italian journey.[118]

Some years later, in 1733, Charles-Antoine Coypel executed two charming and nearly identical cartoons for a handsome Gobelin tapestry entitled "Roland ou les Noces d'Angélique."[119] These illustrate, however, no scene from Ariosto, but an incident in Act iv, scene 5, of Quinault's opera of the same title, first performed in 1637 with music by Lully and repeated many times during the first half and more of the eighteenth century. Here the moment is shown where Roland learns from the shepherdess Bélize the news of Angelica's flight with Medoro (Fig. 37). The painting suggests a *fête champêtre* by Watteau or his followers. Its great arch through which one sees two dancing figures—*personnages de ballet*—surrounded by musicians and spectators and presided over by a fountain nymph framed by a large shell recalling one of François Boucher's elegant fountain designs,[120] the opening of space to the right and the arrange-

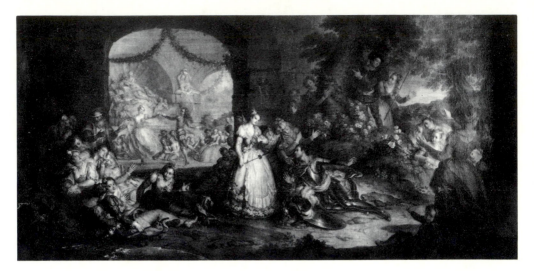

37. Charles-Antoine Coypel, *Roland ou les Noces d'Angélique*. Compiègne, Musée National du Château de Compiègne

ment of the groups are all reminiscent of Watteau's beautiful *Plaisirs du Bal* at Dulwich. At the far right a group of genteel rustics gesture toward a great tree carved by Medoro with amatory inscriptions which a young shepherd points out to his attractive country lass. One may observe that French shepherd swains and their girls, no more than their Italian and Latin forbears, are ever uncouth.

During the last quarter of the century, testifying to the growing enthusiasm for Ariosto, a number of handsome editions of the *Orlando Furioso* were published in Italy and northern Europe. These displayed a wide range of inventive and graphic talent among French and Italian artists, few of whose illustrations, however, convey the rich and full-bodied flavor of the Ariostan spirit.[121] The only example among them of Angelica and Medoro in their pastoral retreat appeared in the famous Baskerville edition published at Birmingham in 1773. Designed by Giovanni Battista Cipriani, an indifferent artist, it is an undistinguished, sentimental version *à la mode* in which Angelica embraces Medoro, interrupting his carving, while a few nibbling sheep insure a bucolic atmosphere.[122] During these years a very few examples of the theme turn up in the Salons or are documented elsewhere.[123]

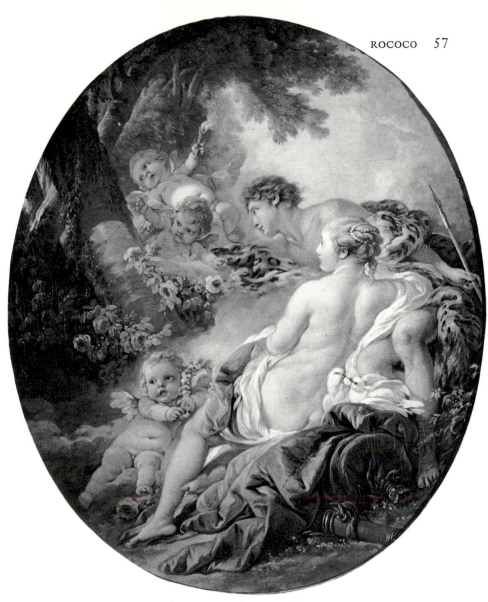

38. François Boucher, *Angelica and Medoro*. Present whereabouts unknown

Ariosto in art, however, save in a very few gallant or comically salacious episodes, is not at home in the elegant atmosphere of the French Rococo, with its often frivolous or juvenile emotions, perhaps least of all in François Boucher's painting, entitled *Angelica*

and Medoro, if indeed that be its subject. The picture (Fig. 38) should date not much before 1765, when, being ill and unable to produce for the occasion, Boucher borrowed it from its owner, Bergeret de Grancourt, to exhibit in the Salon of that year.[124] In this delicious oval, a delicately designed miracle of pervasive arabesque, with its delightful *putti* providing an appropriate amatory accompaniment (one holding aloft the blazing torch), an adolescent nymph reclines while a boyish figure leans forward clutching a festoon of flowers and gazes raptly at the "chiffres"—M/A they appear to be— carved on a large tree. The painting has retained through the years the salon title of *Angelica and Medoro*. But the youth holding a hunter's spear and the girl with a pair of doves nestling behind her, as well as the fact that the "chiffres" are not altogether distinct and the M/A might be read as V/A, suggests that we could have here a *Venus and Adonis* to which Boucher added the motif of initials carved on the tree, readily suggested by French pastoral literature no less than by the text or illustrations of the *Orlando Furioso* itself. In any case the picture is iconographically impure and might best be called a conflation or perhaps a potpourri of Ariosto and Ovid.

The artistic portrayal of Angelica and Medoro in eighteenth-century Italy, where Ariosto's popularity had never succumbed to the blight of critical controversy, shows instructive differences, as far as we can judge from the few examples left us, between Rome and Venice. In the century's early years, the poet's pictorial interpreters in Rome suggest comparison, as critics have pointed out, with contemporary art in France. Benedetto Luti, who succeeded Carlo Maratta as the first painter in Rome, did an *Angelica and Medoro*, Leone Pascoli reports,[125] for the Marchese Torri's villa outside the Porta San Pancrazio, for which three drawings in the Louvre and a pen and wash drawing in the Uffizi appear to be preparatory studies.[126] In the most interesting of the drawings (Fig. 39), the general arrangement of the figures is common to that of similar amorous subjects from Ovid and Tasso where one figure more or less reclines between the knees of the other, save that Luti like the earlier Mannerist artists, whose practice he here revives, has brought together two figures from the perennially vital Sistine Ceiling, an *ignudo* for Medoro, and for Angelica nothing less than the famous figure of the prophet Jonah (Fig. 40). Those devotees who carry Michel-

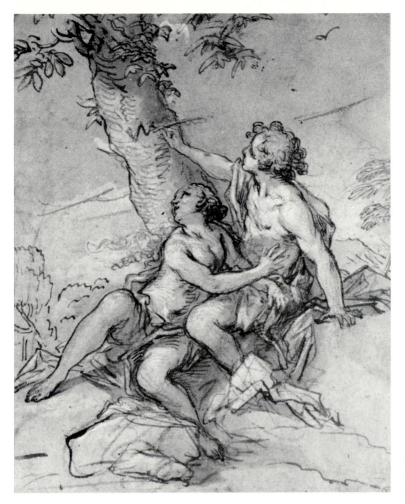

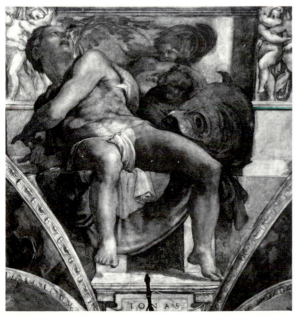

39. Benedetto Luti,
Angelica and Medoro:
drawing. Paris, Louvre

40. Michelangelo, *Jonah*.
Vatican, Sistine Chapel

angelo in their mind's eye may find the quotation in a curious, not to
say frivolous, context. For where in Michelangelo the prophet's
heroic form, forceful movement and ecstatic upward glance express
spiritual illumination, in the strained pose of an amorous Angelica
they are emptied of their original content and become heroics out
of place, mere *forza d'arte*, lacking verisimilitude, and dramatically
vacant. Historically, however, in the fluid contours and curved forms
of this drawing, which, to do it aesthetic justice, has dash and spirit,
we may detect signs of a new style in Luti which corresponds to the
elegant and capricious Rococo in France. Another of the Louvre
drawings (Fig. 41), a beautiful half-length study of the figures of
Angelica and Medoro, is surely a preparatory study for the draw-
ing just discussed. This in its turn is a study for the pen and wash
drawing in the Uffizi, which may well represent Luti's ultimate idea
for the Marchese Torri's picture. In the Uffizi drawing (Fig. 42),
Luti has retained from Michelangelo's Jonah the upturned head
and swinging arm, as well as the general position of the left leg.
But Angelica's right leg is no longer thrust boldly outward, as in
the Jonah and the drawing discussed above, but turned to follow
the direction of the left, to which it is brought closely parallel. The
composition of the figures thus assumes the form of an oval and the
result is no doubt more elegantly erotic in the French sense, but
lacks the vigor of the Louvre drawing.

Rococo tendencies become more evident a little later in Michele
Rocca of Parma, who is in direct line of descent from Correggio and
the Mannerism of Parmigianino.[127] In his painting of *Angelica and
Medoro*, one of several versions, in the Walters Art Gallery in Bal-
timore (Fig. 43), once attributed, it is worth noting, to the French
artist, François le Moine,[128] Rococo tendencies are carried further
and the approximation to French taste appears greater, the curving
patterns being more minutely employed and pervading the whole
picture. The figures still solidly and organically made in Luti's draw-
ing are here fluidly conceived, lacking joint and muscle; gay fan-
tasy, "piquant expression and fastidious elegance" give the picture
its character, none of them, certainly, qualities of Ariosto's poetry
in this episode. But the picture has its own stylistic flair and distinc-
tion and is particularly delightful in the amorous and playful chorus
of flying cupids, one, as in Boucher's picture, holding aloft the hy-

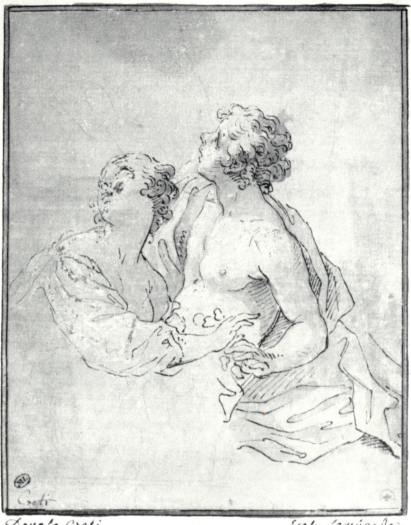

41. Benedetto Luti, study for *Angelica and Medoro*. Paris, Louvre

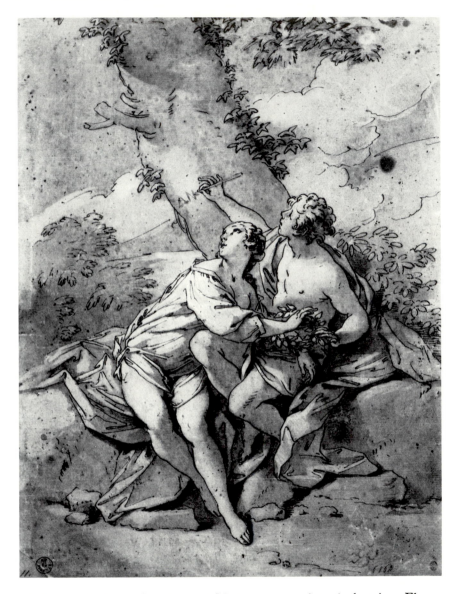

42. Benedetto Luti, *Angelica and Medoro*: pen and wash drawing. Florence, Uffizi

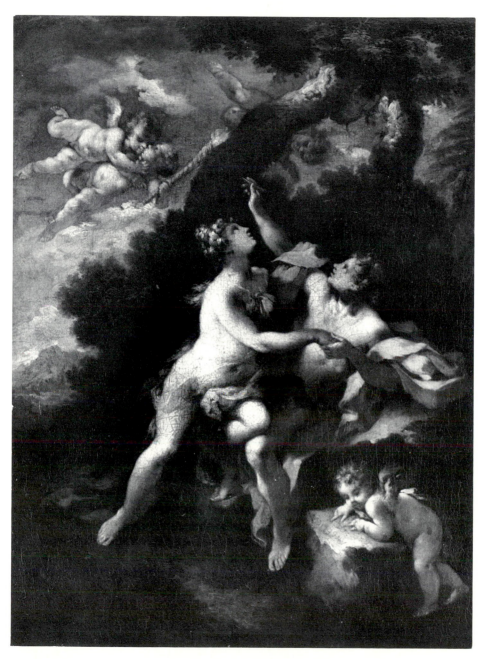

43. Michele Rocca, *Angelica and Medoro*. Baltimore, Walters Art Gallery

menaeal torch, another peering mischievously at the lovers from behind a tree, while still another on the ground runs his finger over the names of Angelica and Medoro, already carved on a large rock.[129]

But if Ariosto's vintage narrative is diluted in such cases by lively exigencies of pictorial style—something similar had happened, as we have seen, at the hands of Mannerist artists—it finds its truest interpretation in the eighteenth century in Venice, where all styles had always served richly human as well as painterly ends. In a picture by Sebastiano Ricci of about 1720, which I came upon by pure chance in the remote Rumanian town of Sibiu at the foot of the Carpathian mountains, poetry changes into painting by an unforced and natural process (Fig. 44).[130] Ariosto's pastoral has a charming

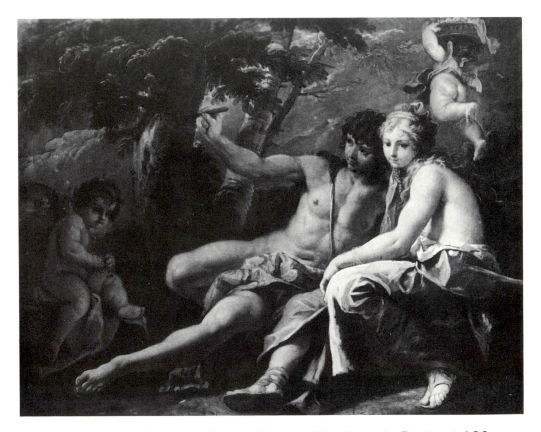

44. Sebastiano Ricci, *Angelica and Medoro*. Sibiu, Rumania, Bruckenthal Museum

pictorial counterpart in this picture of well realized forms and warm sentiment, with its rich chromatic impasto and a splendid play of light and shade which gives an intense and appropriate luminosity to the atmosphere. And the *putto* who gaily absconds into the upper air with a basket of fruit on his head is a memory of Rome appropriate to this Venetian pastoral holiday. His prototype, which Ricci had seen in the Farnese Gallery during his Roman sojourn, flies at the head of an aerial procession of *putti* in Annibale Carracci's *Triumph of Bacchus*.[131] Later in the century Giambattista Tiepolo, last of the great Venetians, portrayed Angelica and Medoro a number of times, for instance in one of his handsomest drawings, now at Oxford, of about 1740 (Fig. 45).[132] Drenched with light and with the pyramidal group of Angelica and Medoro grandly framed by the larger pyramid made by the tree on one side and the massive rock and rude shelter on the other, it reveals a moment of particular understanding between the lovers.[133] Some twenty years after, at the Villa Valmarana in Vicenza, in one of his most abstemious and most elegantly beautiful compositions (Fig. 46), the roles are reversed, as they often are particularly in the eighteenth century: Medoro now loafs on the ground while Angelica, responding to his ardent glance, carves the names on the ample surface of a well selected tree.[134]

Giandomenico Tiepolo was even more attracted than his father to the theme of Angelica and Medoro, and he has left a fascinating series of brilliant pen and wash drawings, variations on a theme, in which Angelica generally carves or points to the carving while Medoro sits or sprawls on the ground. These drawings, often containing features extraneous to the text, like statues and architecture (Fig. 47), are characterized by bizarre poses and energetically expressive contours, so that they seem, at least as compared with the interpretations of his father, so many dynamic exercises in capricious invention, rather than illustrations of Ariosto's poem.[135]

Finally, Americanists may remember that Benjamin West, to try his hand at an Italian poetical subject, and perhaps also to pay a compliment, began a neoclassic and charming *Angelica and Medoro* in Rome in 1763 (Fig. 48). He had met the young Swiss painter Angelica Kauffmann in Florence the year before, perhaps gave her a colleague's advice, and probably was as taken with her airs and

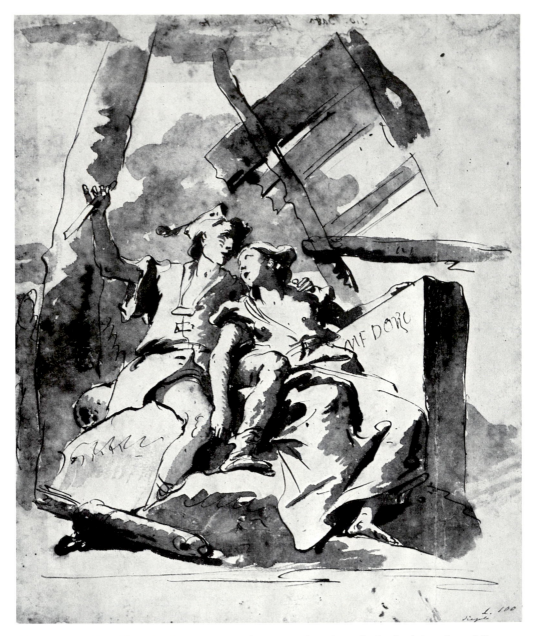

45. Giambattista Tiepolo, *Angelica and Medoro*: drawing. Oxford, Ashmolean Museum

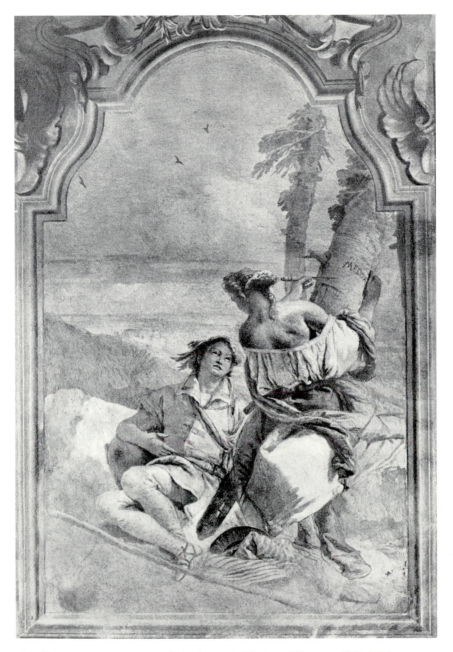

46. Giambattista Tiepolo, *Angelica and Medoro*. Vicenza, Villa Valmarana

graces as Sir Joshua Reynolds and others were to be a few years later in England. There she rivaled Ariosto's Angelica in the number of her suitors, though not, I should think, in narrow escapes. This pic-

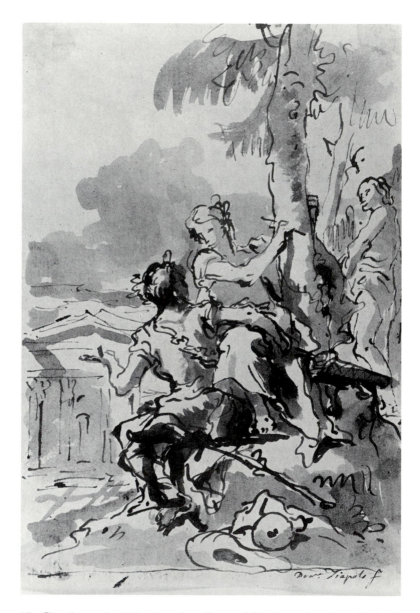

47. Giandomenico Tiepolo, *Angelica and Medoro*: drawing. Oxford, Ashmolean Museum

48. Benjamin West, *Angelica and Medoro*. Binghamton, Museum of the State University of New York

ture West may have taken under his arm when he went to London in 1763, and finished in the autumn of that year, having had a good look, as the landscape background testifies, at the rolling downs and grazing sheep of the English countryside.[136]

ᓚ 7. Pastoral Twilight

During the latter years of the eighteenth century, as we have seen, richly illustrated editions of the *Orlando Furioso* were published, and the first half of the nineteenth occasionally made an interesting contribution to book illustration. In these new volumes Angelica and Medoro in their sylvan setting continue to appear from time to time, depicted in modes that vary from coldly neoclassic[137] to over-sentimentally romantic,[138] none of them very successful in capturing the spirit of Ariosto's warm and candid idyll. The illustrators, anticipating, then reflecting the emotional temper of romanticism, had been since the mid-1770s more partial to the compassionate scene on the battlefield where Angelica tends the wounds of the young soldier,[139] than to the pastoral motif of carving names. By 1844,[140] three years after Ingres had painted his last version with its Gothic references of Ruggiero saving Angelica from the Orca, romantic illustrators of books, strongly predisposed to mediaeval costume and scenography, had produced their best work in depicting the chivalrous, adventurous, martial and fantastic elements in Ariosto's poem. But for the painters, by about 1770, when Giambattista Tiepolo and Boucher died, Angelica and Medoro carving names in their country retreat had about ceased to have significant interest. Occasionally there may be a faint stirring of life in the Salons among painters now forgotten.[141] Better worth recording, perhaps, is a brusque and bizarre sketch of about 1815 in the Magnin Collection at Dijon, attributed to Géricault (Fig. 49).[142] Here Angelica, seated on Medoro's lap—their classical profiles in sharp opposition, their costumes Roman—embraces him with her left arm while her right hand, directed by his left, carves the names. The painting goes almost as far as to convey an impression of moral earnestness, as if carving names on trees were an act of virtue—a curious by-product of Davidian legacy. And in 1825, in an equally distasteful vein which does not so much strain as enfeeble Ariosto's content, the German Nazarene, Julius Schnorr von Carolsfeld, painted Angelica and Medoro in a room in the Casino Massimo in Rome which he covered with frescoes portraying the *Orlando Furioso* (Fig. 50). With prop-

49. Follower of Géricault, ca. 1815, *Angelica and Medoro*. Dijon, Musée Magnin.

50. Julius Schnorr von Carolsfeld, *Angelica and Medoro* and *Orlando Furioso*: cartoon for fresco in the Villa Massimo, Rome, 1825. Karlsruhe, Staatliche Kunsthalle

agandist fervor he ponderously stresses warlike action and Christian victory over the Saracens, offering only pallid relief in his sentimental vision of a listless, rather quattrocento Medoro reclining at the side of a Beatrician, virginal Angelica who rather wanly performs the act of carving, here drained of all amorous vitality.[143] Actually, in the course of the nineteenth century, when in the wake of romanticism, Dante and Tasso, Shakespeare and Goethe provide art with ample literary nourishment, Ariosto still holds his own among the painters. But under the stronger romantic impulses they find the peaceful interlude of Angelica and Medoro little to their taste, preferring scenes of dramatic suspense or violent action. Angelica's perils replace her pastoral. She flees her pursuers in the forest, or faces Sacripante, an uncompromising lover.[144] Above all, in numerous examples we see her either a single figure chained to the rock in lonely anguish and naked beauty, or valiantly delivered from the monster by Ruggiero on the hippogriff.[145] These moments of terror

or martial brilliance entirely eclipse Angelica's idyll which had far outshone them in the preceding centuries. This of course reflected the taste of the period. But it is also important to remember that by the end of the eighteenth century the traditional and conventional pastoral, an artificial form of literature which had delighted courts but had been "largely indifferent to the lot of man in collective terms," had about passed from the stage of European literature. To this tradition, though also transcending it in fresh, ardent and ingenuous humanity, the idyll of Angelica and Medoro is closely bound in its bucolic setting and in the ancient topos of carving names on trees. And it has been well observed that powerful forces of humanitarianism, material progress, the scientific spirit and artistic realism were alike hostile to the fragile and artificial mode of the pastoral.[146] Finally, late in the nineteenth century, the poet William Yeats was to lament that

The woods of Arcady are dead
And over is their antique joy[147]

But more than a century before Yeats wrote these lines, Angelica and Medoro, recording their passion on trees like many Arcadian lovers before them, had had their day in the art of painting.

❧ 8. Variations on a Theme

Names on trees in art are not limited, at least after about 1775, to illustrations of Ariosto and Tasso. But familiarity with the literary tradition and its expression in such works as we have considered may have prompted an occasional artist to use the very human motif in a pictorial invention entirely of his own devising. Fragonard's attractive *Chiffre d'amour* or *Le Souvenir* (Fig. 51) in the Wallace Collection is by an artist who knew the *Orlando Furioso* well. But, unfortunately for this essay, he did not include illustrations of the story of Angelica and Medoro among his famous set of drawings for an edition of the poem, though a score are devoted to Angelica's dramatic earlier history.[148] The Wallace picture shows an alluring young woman carving lovers' initials on a tree; she has completed the letter S and is watched by a dog, the presumptive symbol of faithfulness.[149] Fragonard painted another *Chiffre d'amour*, now lost, which carries the alternate titles of *La belle Julie* and *Angélique écrivant sur un arbre le nom de Médor*.[150] This was engraved by Nicolas de Launay, and the Ariostan title, based on no arboreal inscription proving it correct, is simply indication that the passage in Ariosto and its pictorial illustration were well known. In the nineteenth century, American painting produced an example of the subject in Winslow Homer's early *The Initials* of 1864 (Fig. 52) where a young woman in a melancholy, late autumnal landscape of leafless trees—"bare ruined choirs where late the sweet birds sang"—braves the cold to carve on a large tree, the bark of which already reveals a heart and other insignia of love.[151]

A few less conventional variations on the theme are also worth recording here. Late in the eighteenth century Étienne-Charles Le Guay, who was attached to the factory at Sèvres, painted a small picture now at Dijon which would be very appropriate in miniature for the cover of a porcelain box on a young lady's dressing table. It depicts a cupid carving on a tree the name of La Valière (*sic*) (Fig. 53), a charming recollection of Louis XIV's early love affair of a century before, while with comic irony, probably unintended, the faithful dog looks on.[152] In England in the mid-1850s,

51. Fragonard, *Le Chiffre d'amour*. London, Wallace Collection

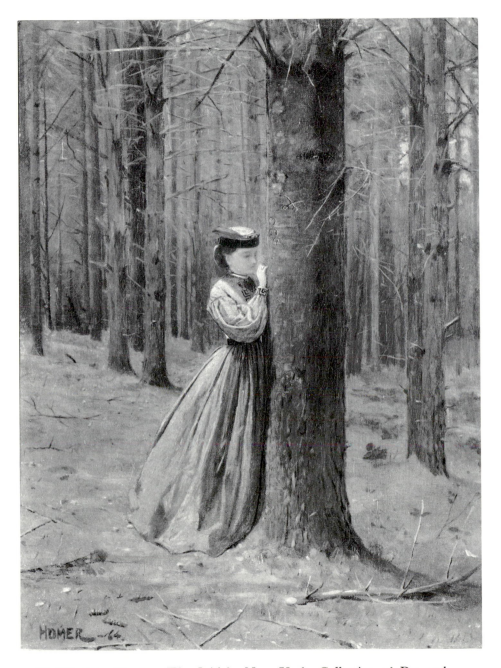

52. Winslow Homer, *The Initials*. New York, Collection of Dr. and Mrs. Irving Levitt

53. Etienne-Charles Le Guay, *L'Amour gravant le nom de la Valière* (*sic*). Dijon, Musée Magnin

Arthur Hughes, who, as Sacheverell Sitwell remarks "became involved in the secondary wave of Pre-Raphaelites" and reflects their conscientious craftsmanship, painted *Amy* or *The Long Engagement*, now in the City Art Gallery of Birmingham (Fig. 54), which, he adds, "it is probable, is the most typical work of the whole mid-Victorian age."[153] The description that follows does full justice, if not more, to the painter's mournful intention: "The curate and his

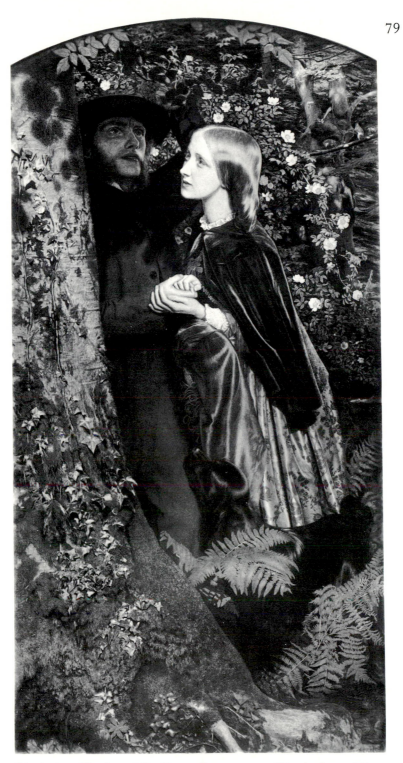

54. Arthur Hughes, *The Long Engagement*. Birmingham, Museum and Art Gallery

betrothed are standing near the tree stem upon which their joint hands have carved her name. Years have gone by and still they cannot afford to be married. All round them nature is fulfilling herself. The trees are in leaf, the little squirrels are playing happily on their branch; even the faithful dog, a symbol so dear to the Victorians, has not, we may understand it, remained celibate; the green moss creeps in a tide up the tree-stem; soon it will obliterate the carved inscription. But the curate and his betrothed remain doomed to solitude." Sitwell then adds—correctly—that the painting shows "a weight of sentiment that overbalances into the comical" but that "it is genuine sentiment and it is not necessary to be reminded how wretchedly underpaid the minor clergy have always been." So besides being a sentimental picture, it is also a reminder of a form of social injustice. Sitwell's remarks may perhaps outreach the symbolism in the picture. His criticism may be an example of that kind of writing in which, as Sir Joshua Reynolds remarked, some critics find in a painting "what they are resolved to find." In any case, both the carefully painted picture and Sitwell's account of it, with all the ecphrastic justification this may have, would raise a storm in the mind of a critic of genuine classical temper, a Lessing for instance.

But carving names on trees has not, since the late eighteenth century, been depicted only as an expressive device of young or, as in Arthur Hughes' example, no longer young lovers. It can, for instance, recall happy hours passed together in the country by men of genius. Thus a sketch in the Norwich Public Library by the landscape architect, Humphry Repton, in which he carves their names on a great tree trunk (Fig. 55), commemorates his visit to Epping Forest in 1789 with his friend and future professional enemy, Richard Payne Knight.[154] And in 1849 in America, Asher B. Durand portrayed as a memorial to another painter, Thomas Cole, the figures of Cole and of the poet, William Cullen Bryant, standing together on a projecting ledge of rock in the wild scenery of the Catskill Mountains, their names carved on a tree at the left.[155] The picture (Fig. 56), now in the New York Public Library, was answer to a request that Durand paint Bryant, and Cole who had recently died, as "kindred spirits," and that is the painting's title, taken from the concluding lines of John Keats' "Sonnet to Solitude":

And it sure must be
Amongst the highest bliss of human-kind,
When to thy haunts two kindred spirits flee.

The picture then expresses the communion with nature which these men shared and expressed in the sister arts of poetry and painting. But it is entirely likely that the long literary use of the motif of carving names and perhaps the ample portrayal in painting and book illustration of Ariosto's lovers combined to provide the suggestive background for the use of the topos in this as in other variations on the theme that we have just considered.

55. Humphry Repton, *"Mr. Knight Carving Our Joint Names"*: drawing. Norwich, Public Library

56. Asher B. Durand, *Kindred Spirits*. New York, Collection of the
New York Public Library, Astor, Lenox and Tilden Foundations

9. Reprise and Epilogue

Historically, as we saw at the beginning, the motif of lovers carving their names on trees has a two-fold significance. It may properly be viewed as a continuation and late moment of the long tradition, beginning in remote antiquity, of regarding nature as a book—in the Latin Middle Ages a book of religious and moral instruction that was gradually secularized with the approach of the Renaissance. But it is also a revival of a motif found in Roman poetry of the Augustan age. Thus it was rediscovery of an ancient theme that added a very human and attractive, though sometimes tinkling and fragile, coda to the serious strain of nature's book as profound teacher which had earlier prevailed.

After Ariosto, carving names was to become, as we observed of certain French writers of the sixteenth and seventeenth centuries, a familiar convention in European pastoral literature, frequently following the elegiac tone of ancient Roman authors. But at times, and this is notably true of English literature, the use of the motif was underivative, fresh and original, especially in writers who found it either a tedious literary cliché or, as an expression of love, "mere folly," perhaps a bubble sure to burst at the touch of reality. Thus Shakespeare, at the end of the sixteenth century gently satirizes the convention when in *As You Like It* Orlando vows he will carve Rosalind's name on "every tree" in the Forest of Arden,[156] a bucolic labor of Hercules. In the next century Andrew Marvell, lover of gardens and trees, an early conservationist, chides lovers for their habit of wounding fine trees with the names of girls who cannot compare with them in beauty.[157] As we move forward, Henry Fielding in the mid-eighteenth century, depicting the natural man, employs the motif with comic irony: for when Tom Jones, about to carve the name of his chaste and beloved Sophia on a tree, is interrupted by the approach of Molly Seagrim, the blacksmith's daughter, he drops his knife and with no high principles follows her into a thicket.[158] By extreme contrast to Fielding, Isaac Watts, a religious poet of genius, in his "Meditation in a Grove," had earlier twisted the terrestrial convention to the uses of mystical religious exercise,

declaring that in the evening shadows of this place, the name of no earthly flame, no Phyllis, will be found, but every tree wounded with his knife will bleed with the name of Jesus, testifying to heavenly not earthly love.[159] In such cases an old convention is revitalized and put to new imaginative uses. And it carried on in literature, imbued with new freshness and charm, into the nineteenth century, recurring in German romanticism in Wilhelm Müller's poems *Ungeduld* and *Der Lindenbaum*, both set to music by Schubert,[160] and in England in Alfred Tennyson's *Talking Oak*.

But what became literary usage and then, as we have seen, passed into art existed long before Virgil and Ovid as a perennial practice of youth in love, and the Angelicas and Medoros of our day still carve or write their names *hic et ubique*—on trees, rocks and walls à l'antique as well as on clothes posts, restaurant tables and the backs of church pews. But now, as epilogue to this essay, let us return to art, which is said to improve upon nature, and glance at what must be the most florescent visual example of the youthful activity, gay, foolish, or as the ancients first perceived, poignant, which we have here been considering. In a beautiful drawing by Pietro da Cortona in the Pierpont Morgan Library in New York (Fig. 57) we see a veritable explosion of springtime sentiment. Not one or two, but five lovely girls, are carving at the same moment the names and praises of their lovers on the bark of splendid trees.[161] What is the literary source of this fine drawing? I have found none, and stand ready to believe that it sprang full armed from the artist's head and hand. But if any learned reader can counter so naïve a view, I shall be glad to listen to him.

Opposite: 57. Pietro da Cortona, *Girls Inscribing Trees*: drawing. New York, Pierpont Morgan Library

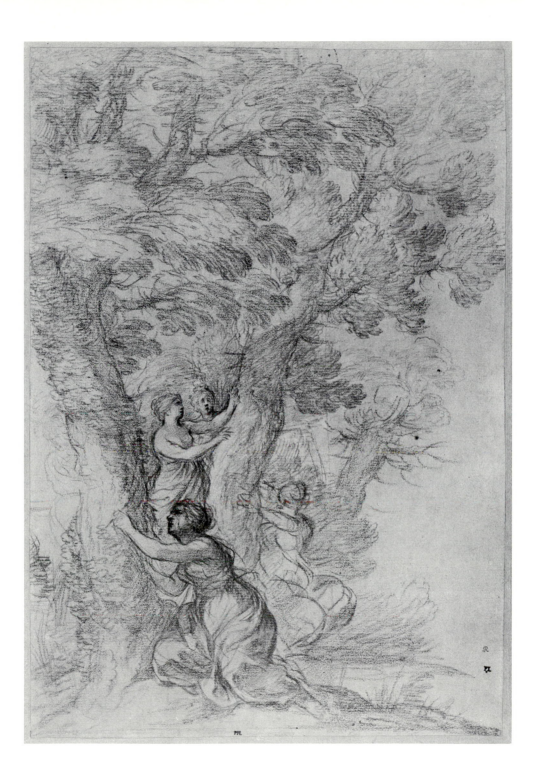

Notes

1. Edmund Spenser in his *Faerie Queene* (VII, 7, 9) recalls Chaucer's admission of indebtedness to Alan's *De planctu Naturae* in the *Parlement of Foules* (316-318). Spenser was himself beholden to Alan's poem in *Faerie Queene* VII, 7, 5-13 (see H. G. Lotspeich, *Classical Mythology in the Works of Edmund Spenser*, Princeton, 1932, pp. 87-88), and probably in IV, 10 (see G. C. Smith, *Spenser's Theory of Friendship*, Baltimore, 1930, pp. 69-71, and R. Tuve, "A Mediaeval Commonplace in Spenser's Cosmology," *Studies in Philology*, vol. XXX [1933], pp. 133-143).

2. *Patrologia Latina*, vol. 210, 579A:

> *Omnis mundi creatura*
> *Quasi liber et pictura*
> *Nobis est et speculum.*

3. In a famous passage derogatory to art (*Republic*, x, 596), Plato had early referred to the mirror as reflecting the mere appearances of things, not archetypal reality, but in the high Middle Ages, as in the famous *Speculum Majus* of Vincent of Beauvais, the mirrors of Nature, Knowledge, Morals and History, which reflect the ordinances of God as illustrated in the world, are instruments of instruction. For interesting remarks on the mirror as metaphor from antiquity forward, see E. R. Curtius, *European Literature and the Latin Middle Ages*, trans. W. R. Trask, New York and Evanston, 1963, p. 331, n. 56. I am greatly indebted to Curtius, in the first section of this essay, both for precept and example, notably to his chapter "The Book as Symbol," pp. 302-347.

4. *Ennead* II, chap. 3, sec. 7, trans. Stephen McKenna.

5. *Op. cit.*, p. 304.

6. Chap. 6, 14: "et caelum recessit sicut liber involutus" (cf. Isaiah, chap. 34, 4: "complicabuntur sicut liber caeli"—"the heavens shall be rolled together as a scroll"). And see Curtius' comment on Dante's use of the metaphor, *op. cit.*, pp. 331-332.

7. *Paradiso*, XXIII, 112-113:

> *Lo real manto di tutti i volumi*
> *Del mondo. . . .*

8. *Ibid.*, XXXIII, 86-87:

> *Legato con amore in un volume*
> *Ciò che per l'universo si squaderna;*

9. *Patrologia Latina*, vol. 210, 456b.

10. Sermon on Job, chap. 9, 7-15 (*Opera Omnia*, eds. C. Baur, E. Cunitz and E. Reuss, 1863-1900, vol. XXXIII, col. 428; the date is 1554. Calvin more usually refers to the world of nature as a mirror (See T.H.L. Parker, *The Doctrine of the Knowledge of God*, Edinburgh and London, 1952, p. 18). I am indebted to Roland M. Frye for calling my attention to the passage in Calvin and also to those in Bacon (see note 13 below).

11. Quoted by Curtius, *op. cit.*, pp. 321-322.

12. *Religio Medici* (1642), I, chap. 15.

13. *The Advancement of Learning*, bk. I, in the World's Classics ed., Oxford and London, 1929, p. 46 (first ed. 1605), and cf. p. 11 where Bacon speaks of "the book of God's word or the book of God's works" neither of which can be studied to excess. John Milton, well past the middle of the seventeenth century, was still very much aware of the concept of nature as a book of knowledge in which God's hand is apparent. In *Paradise Lost* (1667), VIII, 66ff., the Archangel Raphael tells Adam that

> *'Heaven*
> *Is as the Book of God before thee set*
> *Wherein to read his wondrous works and learn . . .'*

And in III, 46ff., lamenting his blindness, the poet writes that he is

> *for the book of knowledge fair*
> *Presented with a universal blank*
> *Of Nature's works to me expung'd and ras'd,*
> *And wisdom at one entrance quite shut out.*

Here the book of knowledge is nature perceived by the sense of sight; living now in darkness, Milton then prays that in telling "things invisible to mortal sight" the inward eyes of the mind may be illumined by "Celestial Light."

14. *Essais* (1580), I, 26.

15. *Twelfth Night*, Act I, Scene 4, 13-14:

> *I have unclasp'd*
> *To thee the book even of my secret soul.*

16. *As You Like It*, Act II, Scene 1, 12-17; cf. Milton, *loc. cit.* in note 13 above.

17. *Purgatorio*, XXXII, 100.

18. *As You Like It*, Act I, Scene 1, 124-125.

19. *Ibid.*, Act III, Scene 1, 5-6.

20. *Acharnians*, 143-144 (performed in 425 B.C.) where an admirer

of Athens is said to have scribbled Ἀθηναῖοι καλοί on every wall. The Scholiast's comment on these lines is that it was peculiar to lovers to write names of their beloved on the walls of houses, trees and leaves. See P. J. Enk, *Sex. Propertii Eligiarum,* Leyden, 1946, p. 165 where in his commentary on Propertius' *Elegies,* bk. I, XVIII, 22, he lists examples of writing on trees in Greek, Latin and English literature.

21. *Aetia,* no. 73, Loeb Classical Library, 1958, p. 53: "But on your bark may you bear so many carved letters as will say that Cydippe is beautiful." Cf. *The Greek Anthology,* Loeb Classical Library, vol. IV, pp. 347-348, no. 129, and especially no. 130: ". . . I will still say it, that Dositheus is fair and has lovely eyes. These words we engraved on no oak or pine, no, nor on a wall, but Love burnt them into my heart."

22. *Idyll,* XVIII, 47: γράμματα δ' ἐν φλοιῷ γεγράψεται.

23. *Eclogue,* X, 52-54:

> *Certum est in silvis, inter spelaea ferarum*
> *Malle pati tenerisque meos incidere amores*
> *Arboribus; crescent illae, crescetis amores.*

For valuable comment on this passage and on the related passage in Propertius discussed below, see M. C. J. Putnam, *Virgil's Pastoral Art,* Princeton, 1970, pp. 372ff. For verses carved on beech bark, cf. *Eclogue,* V, 13-15.

24. *Heroides,* V, 21-22, 25-26:

> *Incisae servant a te mea nomina fagi,*
> *Et legor OENONE falce notata tua.*
> *Et quantum trunci, tantum mea nomina crescunt.*
> *Crescite et in titulos surgite recta meos!*

Lines 23 and 24 are omitted as spurious (see the Loeb Classical Library edition, 1914, with G. Showerman's translation, p. 58).

25. *Ibid.,* 27-32.

26. *Elegies,* bk. I, XVIII, 1-4, 19-22:

> *Haec certe deserta loca et taciturna querenti,*
> *Et vacuum Zephyri possidet aura nemus.*
> *Hic licet occultos proferre impune dolores,*
> *Si modo sola queant saxa tenere fidem.*
>
>
>
> *Vos eritis testes, si quos habet arbor amores,*
> *Fagus et Arcadio pinus amica deo.*
> *A quotiens teneras resonant mea verba sub umbras,*
> *Scribitur et vestris Cynthia corticibus!*

Cf. Petrarch's famous sonnet beginning "Solo e pensoso i più deserti campi / Vo mesurando . . .," in *Le Rime*, ed. N. Zingarelli, Florence, 1926, xxxv, p. 26, and passages of like content in cxvi, cxxvi and cxxxix.

27. See Enk, *op. cit.*, for examples from Calpurnius (first century A.D.), and from P. Annius Florus (a friend of Hadrian), as well as from the Greek of Aristaenetus, *Epistula*, I, 10 (translated into English by the dramatist Richard Brinsley Sheridan and N. B. Hallhead in *Love Epistles Translated from the Greek*, London, 1771), and from Lucian's *Amores*, which contains the famous story of the young man who fell in love with Praxiteles' Aphrodite of Cnidos and "as his passion grew more inflamed, every wall came to be inscribed with his messages and the bark of every tender tree told of fair Aphrodite" (Loeb Classical Library, Lucian, *Amores*, trans. M. D. Macleod, London, 1967, p. 174).

28. *Opere Volgari, Amorum Libri*, ed. P. V. Mengaldo, Bari, 1962, p. 76, 64ff.:

> *Tu, che hai de la mia mano il bel signale,*
> *Arbor felice, e ne la verde scorza*
> *Inscritta hai la memoria del mio male*
> *Strengi lo umor tuo tanto che si smorza*
> *Quel dolce verso, che la chiama mia*
> *Che ognor che io il lego a lacrimar mi forza.*

29. The bulk of the *Arcadia* was written between 1482 and 1489. See Jacopo Sannazaro, *Arcadia and Piscatorial Eclogues,* trans. R. Nash, Detroit, 1966, p. 22. For the Italian text, see Jacopo Sannazaro, *Opere volgari*, ed. A. Mauro, Bari, 1961 (Scrittori d'Italia, no. 220). In notes 30-33 below the first reference is to Nash's translation, the second to the Italian text.

30. Pp. 47-48, 54-66; p. 23, 53-65.

31. P. 34, 103-106; p. 9, 103-106.

32. P. 57; p. 34, 13. The same sentiment from the same antique sources (cf. also the example from Tasso's *Aminta* cited below, note 68) occurs in English literature in Edmund Spenser's pastoral poem, *Colin Clouts Come Home Again* (1595), in a passage (629ff.) written in praise of Queen Elizabeth:

> *Her name recorded I will leave for ever.*
> *Her name in every tree I will endosse*
> *That, as the trees do grow, her name may grow;*
> *And in the ground each where will it engrosse,*
> *And fill with stones, that all men may it know.*

The last two lines are Spenser's original variation on a theme.

33. P. 29; p. 3, 2.

34. They are of course literary shepherds, for Arcadia is a projection of the imagination in which sophisticated people masquerading as "uncouth swains" find repose and relief from the burdensome life of courts and cities. For Virgil's transformation of the region of Arcadia in Greece described by the historian Polybius as a poor, unfertile, inhospitable country, barely affording enough food for flocks and frugal shepherds, into a nostalgic realm of the imagination, see E. Panofsky, "Et in Arcadia Ego: Poussin and the Elegaic Tradition," in *History and Philosophy, Essays presented to Ernst Cassirer*, Oxford, 1936, pp. 224ff. (reprinted in his *Meaning in the Visual Arts*, New York, 1955, pp. 295ff.). For the pastoral psychology, cf. R. Poggioli, "The Oaten Flute," *Harvard Library Bulletin*, 1959, 147-184, reprinted as one of fourteen brilliant essays by Poggioli on various types of pastoral in *The Oaten Flute*, Harvard University Press, Cambridge, 1975, pp. 1-41. A. Bartlett Giamatti, who edited these essays, has added a valuable bibliographical note (pp. 315-316) on past and recent studies related to the pastoral.

35. Further to Angelica's character and her significance in the poem, see R. W. Lee, "Ariosto's Roger and Angelica in Sixteenth-Century Art," in *Essays in Honor of Millard Meiss*, New York, 1977, including notes 4-7. Cf. note 39 below.

36. The only sixteenth-century example in painting that I know is a now badly deteriorated series of six frescoes filling small lunettes in a vaulted room in the Osteria della Ferrata, at Chiusa di Pesio in Piedmont, some forty miles south of Turin; the room was in the sixteenth-century part of the Palazzo of the Marchesi di Ceva. These frescoes, painted in a narrative style recalling Defendente Ferrari, must once have had great charm. For their date (after 1542) and their dependence on book illustration, see R. W. Lee, "Adventures of Angelica: Early Frescoes Illustrating the *Orlando Furioso*," in the *Art Bulletin*, vol. LIX, 1977. Angelica's early adventures were not to be given as full a visual interpretation until the late eighteenth century in a series of drawings for the *Orlando Furioso* by Fragonard (see E. Mongan, P. Hofer and J. Seznec, *Fragonard, Drawings for Ariosto*, New York, 1945, pls. 1-8).

37. This particular moment (Canto 1, 17) was first illustrated in the edition published in Venice in 1530 by Nicolò Zoppino, where the woodcuts have the quasi primitive character of late fifteenth-century book illustration. The cuts in the volume of 1542 were repeated in many subsequent editions of Giolito. The same moment, combined with other incidents

in the first Canto, was depicted around the mid-century in the Venetian editions of Andrea Valvassori (1553 and later) and of Vincenzo Valgrisi (1566 and after). See G. Agnelli and G. Ravegnani, *Annali delle edizioni Ariostee*, Bologna, 1933, pp. 95ff. (They do not, however, list the rare first Valvassori edition of 1553, which Enid Falaschi has kindly called to my attention. A copy is in the British Museum.)

38. The painting had gone to England from Spain in 1632 as a present from Philip IV to the Prince of Wales, later King Charles I. In June, 1629, Rubens went on a diplomatic mission to the English court and undoubtedly saw the King's paintings. The *Angelica and the Hermit* has been plausibly dated for stylistic reasons between 1630 and 1635 (see Pierre Cabanne, *Rubens*, New York, 1969, p. 226; for the "Pardo Venus" see E. Panofsky, *Problems in Titian*, New York, 1969, p. 190 and pl. 197).

39. See R. W. Lee, "Ariosto's Roger and Angelica," both for Ariosto's dependence on Ovid's account in *Metamorphoses*, IV, and for a most likely source for Roger riding the hippogriff in Pierre Bersuire's *Ovidius Moralizatus* of about 1340.

40. In the catalogue of the 1955 exhibition at Venice, "Giorgione e i Giorgioneschi" (ed. P. Zampetti), p. 212, fig. 101 on p. 213, this painting, which once belonged to Lionello Venturi, bears the unlikely attribution to Girolamo Romanino and is labeled *Perseus and Andromeda*. It had earlier carried the attribution to Romanino in an exhibition entitled "Giorgione and his Circle," held in 1942 at The Johns Hopkins University, Baltimore (see the 1942 catalogue, p. 41).

41. Ingres was enamored of the subject, of which he painted three complete and similar versions: the earliest, of 1819, now in the Louvre (Fig. 4), the London version of 1839, and one of 1841, now at Montauban. See R. Rosenblum, *Ingres*, New York, 1967, p. 138 and cf. p. 140. For a number of nineteenth-century salon paintings devoted to this subject, see the list in G. Rouchès, "L'Interprétation du Roland Furieux dans les arts plastiques" in *Études Italiennes*, II, 1920, pp. 137ff.

42. Other versions by him are in the Museum of Modern Art, New York (see J. Selz, *Odilon Redon*, Lugano, 1971, illustration opp. p. 57) and in the Kröller-Müller Museum, Otterlo. For this last, a more traditional portrayal, see the *Redon Exhibition Catalogue*, Mathiesen Gallery, London, May-June, 1954, no. 84 and illustration. I am indebted to my old friend, the late Hans Hahnloser, for calling my attention to his Redon and supplying a photograph.

43. This illustration, the earliest devoted to this moment that I know, is by Charles Nicolas Cochin *fils* for the richly illustrated edition of the

Orlando Furioso published in Paris in 1775-83. An ingenious version, a sculptural tour de force, was executed in 1840 by Barye; here the coils of the dead Orca form a base for the airborne hippogriff and his riders (see *Sculptures by Antoine Louis Barye*, Metropolitan Museum of Art, New York, 1940, pl. 24). Delacroix in 1860 painted Ruggiero and Angelica flying through the air, but on the back of a horse, not a hippogriff (see A. Robaut, *L'Oeuvre complet de Eugène Delacroix*, Paris, 1885, p. 377, no. 1406). Two sketches for the subject are in the Louvre (see the catalogue of the Delacroix exhibition at the Louvre in 1930, p. 232, no. 526).

44. Canto XI, 1ff.; for illustration of this comic episode see Lee, "Roger and Angelica," figs. 19 and 20. For the attribution to Bilivert, cited by Baldinucci, see M. Gregori, "Postilla ritardata a due Mostre," *Bolletino dell' Accademia degli Euteleti*, 1961, n. 33, p. 107, tav. 39. I am much obliged to Evelina Borea Previtali for this reference.

45. The full episode includes stanzas 16-40.

46. *The Oaten Flute*, Cambridge, 1975, pp. 9ff.

47. For the *Amor*, see H. Voss, *Die Malerei des Barock in Rom*, p. 78, and cf. the Sistine *ignudi* illustrated in C. de Tolnay, *Michelangelo*, vol. II, *The Sistine Chapel*, Princeton, 1945, pls. 95, 96, 106, 108, notably for the position of the legs.

48. See Denis Mahon's comment on the picture in the catalogue of the Wildenstein exhibition, *Artists in Seventeenth-Century Rome*, London, 1955, pp. 78-79. Accepting Briganti's date of the late 1630s, he remarks that it was painted when "the fairly young Romanelli" was "under the strong influence of his master Pietro da Cortona." He then places it in its artistic and cultural setting, observing that "it is more or less contemporary with Cortona's Barberini ceiling, with Poussin's neo-Venetian phase, and (presumably) with some of Pietro Testa's most attractive Arcadian productions." A close copy of Rosselli's picture (Fig. 9) is in the depot of the Kunsthistorisches Museum in Vienna. An eighteenth-century example of the scene, painted by Jean Baptiste Suvée (1743-1800), in the Musée des Beaux-Arts at Nantes, shows Angelica standing at Medoro's side, after descending from her horse. See the 1953 catalogue, p. 194, no. 717, where the painting is wrongly entitled *Tancrède soutenu par Herminie*. This subject from Canto XIX of Tasso's *Gerusalemme Liberata*, where a woman discovers the warrior whom she loves near death and bends over him to staunch his wounds, is comparable to Ariosto's in elegiac content, and Angelica's discovery of Medoro was certainly a literary source for it. Illustrations of Ariosto were occasionally misread as those of Tasso. The Mahon

Romanelli discussed above was engraved in the late eighteenth century by Jean Charles Le Vasseur and wrongly entitled *Tancrède et Herminie*. An example of the engraving is in the Bibliothèque Nationale in Paris. For the relationship of the pictorial compositions of *Tancred and Erminia* to those of sorrowful content in antique and Christian art, see R. W. Lee, "Mola and Tasso" in *Studies in Renaissance and Baroque Art presented to Anthony Blunt*, London and New York, 1969, pp. 140-141.

49. In the adventurous and martial context of most sixteenth-century book illustrations of the *Orlando Furioso*, the scene of Angelica tending the wounds of the young soldier in Canto XIX appears much earlier and far more frequently than the pastoral episode of their carving names on trees that was to become so popular in the art of the following centuries. In a large number of cinquecento editions where the engravings are of the panoramic type showing many or all of the incidents in a given canto, Angelica is seen staunching Medoro's wounds in the middle distance. The figures are minuscule and unlikely to have had any influence on painting of the subject; see the mid-century illustrations for Canto XIX in the many editions of Valvassori and Valgrisi (cf. note 37 above) and of Francesco de Franceschi, Venice, 1584. In this last Angelica is also seen both discovering Medoro as she rides through the forest, and gathering the healing herbs. An edition published in Venice in 1563 by Giovanni Varisco is, I believe, the first to devote the illustration for Canto XIX entirely to Angelica caring for Medoro, again a Lamentation composition in which the shepherd supports Medoro from behind (cf. the edition of 1584), and Angelica bends over him. This same figure composition was to recur in important French editions of the eighteenth and nineteenth centuries, e.g. Paris, 1775-83 (translated by d'Ussieux) with illustrations by Charles Nicolas Cochin *fils*, and Paris, 1844 (trans. Philipon de la Madeleine). In the notable editions of Antonio Zatta, Venice, 1772, the shepherd does not support Medoro, but is seated on his horse, and in that of F. Knab (trans. Mazuy), Paris, 1839, he stands. All of these illustrations resemble, sometimes closely, those of earlier or contemporary portrayals of Tancred and Erminia (see previous note) and like these reach back ultimately to representations of antique and Christian subjects of like content.

50. See E. Schleier, "Aggiunte a Guglielmo Cortese detto il Borgognone" in *Antichità viva* IX, 1970, p. 8, fig. 34. The central group of figures was virtually copied by Pier Francesco Mola in a drawing at Berlin-Dahlem of *Angelica and Medoro* (*ibid.*, p. 17, fig. 35). I am grateful to Dr. Schleier for lending me a photograph of Lanfranco's painting.

51. It is in the depot of the Palazzo Rosso and carries an attribution

to Domenico Fiasella. A drawing of Angelica and Medoro by this artist is listed in O. Grosso, *Catalogo della Galleria di Palazzo Bianco*, Genoa, 1909, p. 38, no. 4.

52. A drawing in the Fitzwilliam Museum at Cambridge with an old attribution to Sisto Badalocchio (circle of Guercino would be safer) also shows a cupid pounding herbs while Angelica bends over Medoro and heals his wounds (I am indebted to Mr. Malcolm Cormak of the Fitzwilliam Museum for calling this drawing to my attention). And a painting attributed to Battista Caracciolo and advertised in the *Burlington Magazine*, CXII, July 1970, p. xxxiii, where it is reproduced, shows the shepherd standing with a handful of herbs behind Angelica, who kneels by Medoro.

53. For the Valmarana frescoes, see R. Pallucchini, *Gli affreschi di Giambattista e Giandomenico Tiepolo alla Villa Valmarana di Vicenza*, Bergamo, 1945, pp. 13, 29-31 and pls. 30-39; A. Morassi, "Giambattista e Domenico Tiepolo alla Villa Valmarana," *Le arti*, 1941, pp. 251-262 and *A Complete Catalogue of the Paintings of G. B. Tiepolo*, New York, 1962, p. 651. For a fine drawing for the fresco of Angelica tending Medoro's wounds, see G. Knox, *Catalogue of the Tiepolo Drawings in the Victoria and Albert Museum*, London, 1960, p. 83 and pl. 249. Other drawings in the Victoria and Albert Museum and at Trieste have been associated with the Villa Valmarana fresco; these for stylistic reasons Knox dates during the earlier Würzburg period of 1750-53 and believes to be studies for the painting of *Apollo and Hyacinth* of ca. 1753 in the Thyssen Collection at Lugano (*ibid.*, p. 73). But cf. G. Vigni, *Disegni del Tiepolo*, Venice, 1942, p. 69, who, though with some uncertainty, relates all these drawings to the Villa Valmarana fresco. In *Disegni del Tiepolo* (catalogue of the exhibition at Udine in 1965) A. Rizzi considers the verso of a drawing in the museum at Trieste (the recto he sees as an *Apollo and Hyacinth* of earlier date) to represent Angelica tending Medoro's wounds. It is, he believes, preparatory in style to a series, including the drawing in the Victoria and Albert Museum mentioned above, for the Villa Valmarana frescoes of 1757. For drawings of this subject by Giandomenico Tiepolo see below, note 135.

54. In the Valvassori editions of 1553 and after, and in the Valgrisi editions beginning in 1556, one sees in the background the shepherd leading Angelica and Medoro, both mounted, to his house. Cf. note 49 above.

55. See L. Johnson's remarks on the picture in the *Catalogue of the Exhibition of the Arts Council of Great Britain*, held at Edinburgh in 1964, p. 41, no. 74. He is reasonably inclined to date the incomplete pic-

ture closer to 1860 than to the date of 1850 given it by Robaut (*Delacroix*, Paris, 1885, no. 1164). Cf. R. Huyghe, *Delacroix*, New York, 1963, pp. 482-483. Long before Delacroix, René Théodore Berthon had exhibited in the Salon of 1810 a painting of Medoro being helped from his horse before the house by Angelica and the shepherd, a Descent from the Cross type of composition. It was engraved by Jean Gudin (Paris, Bibl. Nat. BA GL 3308). I am greatly indebted to Mr. and Mrs. Van Leer for permission to publish their Delacroix, and to Betsy Jones of the Smith College Museum of Art for supplying a photograph.

56. He admired Ariosto not, however, as one might have thought, for his romantic quality of fantastic imagination, but for the beautiful evenness of his art and the range of his perceptions of life: "Que dire de l'Arioste, qui est toute perfection, qui réunit tous les tons, toutes les images, le gai, le tragique, le convenable, le tendre?" (*Journal* II [ed. Joubin, Paris 1932 and 1960], September 7, 1854, p. 258). This view of Ariosto which very perceptibly ranges him among artists of classical temper, as opposed to such geniuses as Shakespeare and Homer whose workmanship is uneven but who compel the imagination with powerful effects of the sublime or grotesque (cf. *ibid.*, October 26, 1853, pp. 102-104) is interesting in Delacroix who, when he came to illustrate Ariosto, as in the *Angélique et Médor*, endowed the subject with an air of literary romanticism which Ariosto's text scarcely suggests.

57. A small painting attributed to Rembrandt in the Wallace Collection is probably an old copy after a lost original that served for his etching of the subject. Here the wounded man on the horse has arrived at the inn and is being helped to dismount by the Good Samaritan (see A. Bredius, *Rembrandt*, ed. London and New York, 1969, pl. 458, and p. 605, note 545, but cf. L. Münz, *A Critical Catalogue of Rembrandt's Etchings*, London, 1952, II, no. 196 and pp. 93-94). In Van Dyck's painting of ca. 1620, once in a Polish private collection (*Klassiker der Kunst*, 1909, ed. E. Schaeffer, pl. 18), he is being helped onto the horse. A late cinquecento example by Domenico Campagnola had shown him supported by the Samaritan, who prepares to mount him on the beast (*Samuel H. Kress Collection Catalogue*, London, 1968, I, p. 191, fig. 443). For Delacroix's painting, see R. Escolier, *Delacroix*, Paris, 1929, p. 158; the preparatory drawing for it is reproduced on p. 155. Domenico Feti's *Good Samaritan* in the Metropolitan Museum bears such a strong resemblance to Delacroix's picture that it could have served as its model. Delacroix's second version of 1852 in the Victoria and Albert Museum shows the Good Samaritan supporting the head of the wounded man as he lies

on the ground (see R. Huyghe, *op. cit.*, p. 483, pl. 369). This is in line with the more usual tradition both in Italy and northern Europe. Van Gogh, moved no doubt by its compassionate sentiment, copied the 1850 version from a lithograph by J. Laurens at Saint-Rémy in May, 1890.

58. Canto XXX, 16.

59. The names "Angelica and Medoro" which the lovers carve on the walls and doors of the shepherd's house and on neighboring trees and rocks are seen by Orlando, forever in search of Angelica, in Canto XXIII. This is the beginning of his madness which, further stimulated, erupts at the end of the Canto (see stanzas 100-136 and Canto XXIV, 1-14). Cf. Figure 50.

60. *Aeneid*, IV, 160ff.

61. Canto IX, 36 (the translation in the text is Allan Gilbert's, New York, 1954):

> *Fra piacer tanti, ovunque un arbor dritto*
> *Vedesse ombrare o fonte o rivo puro,*
> *V'avea spillo o coltel subito fitto;*
> *Così, se v'era alcun sasso men duro.*
> *Ed era fuori in mille luoghi scritto,*
> *E così in casa in altri tanti il muro*
> *Angelica e Medoro, in vari modi*
> *Legati insieme di diversi nodi.*

62. See pp. 9-11 above.

63. *Les XXI epistres d'Ovide translatees de latin en francays par reverend pere en Dieu Monseigneur l'evesque d'Angoulesme*, Paris, Anthoine Vérard (Bibliothèque Nationale, Velins, 2089) no date but bearing Vérard's mark.

64. See p. 9 above.

65. One of a series of four classical subjects, two of them dated 1539 (see A. Bartsch, *Le Peintre graveur*, VIII, pp. 340-341, nos. 70-73). For Pencz's *curriculum vitae* and his relations to Italy, see H. G. Gmelin, "Georg Pencz als Maler," *Münchner Jahrbuch*, III Folge, XVI (1966), pp. 49-126; G. van der Osten and H. Vey, *Painting in Germany and the Netherlands, 1500 to 1600*, 1969, p. 233; and earlier, P. Kristeller, *Kupferstich und Holzschnitt in vier Jahrhunderten*, Berlin, 1922, p. 246, who also gives a good evaluation of the quality of Pencz's work under Italian influence. I have not been able to decipher the inscription carved on the tree.

66. See the lists in A. Pigler, *Barockthemen . . .* , II, pp. 463ff. Budapest, 1974.

67. The 1577 cuts are in the edition published "appresso gli Heredi di Pietro Deuchino" (Dehuchino). They were repeated in the Venetian editions of Paolo Zanfretti, 1582, and of Nicolò Misserino, 1600 and 1609. It should be noted that in the Valgrisi editions, beginning in 1556, the initials A. M. are seen on a tree at the right, first intimation of the actual scene of carving that was only to appear twenty-one years later. The first Dehuchino edition of 1574 has a different cut for Canto XIX. The editions mentioned here are listed under their dates in Agnelli and Ravegnani, *Annali delle edizioni Ariostee*, I.

If a drawing in the Albertina by Giulio Romano and the engraving after it by Marcantonio Raimondi (also the imitation of this engraving in reverse by Agostino Veneziano) represented Angelica and Medoro, these would be by over half a century the earliest examples of the subject in art. But though engravings and drawing (this for one of the frescoes in Cardinal Bibbiena's bathroom in the Vatican finished in 1516) are labeled respectively *Angelica and Medoro* in Bartsch, XIV, p. 359-360, nos. 484-485, and in volume III of the Albertina Catalogue, *Die Zeichnungen der Toskanischen, Umbrischen und Römischen Schulen*, Vienna, 1932, no. 80, p. 14, they have no distinguishing marks of Ariosto's subject and their correct title is *Venus and Adonis* (see F. Hartt, *Giulio Romano*, New Haven, 1958, I, p. 31, no. 10; II, figs. 49, 50).

68. In the *Aminta*, I, I, 318ff., Dafne, seeking to persuade Sylvia to love Aminta, tells how Thyrsis, in love, wrote verses on trees:

> . . . *Or tu non sai*
> *Ciò che Tirsi ne scrisse, allor ch'ardendo*
> *Forsennato egli errò per le foreste,*
> *Si che insieme movea pietate e riso*
> *Ne le vezzose ninfe e n' pastori?*
>
>
>
> *Lo scrisse in mille piante, e con le piante*
> *Crebbero i versi. . . .*

In the last lines quoted, which tell how the inscribed verses grew with the trees, Tasso clearly follows Virgil and Ovid (see p. 9 above). The *Aminta* was first staged in the presence of Alfonso of Ferrara and his court on the island of Belvedere in the midst of the Po; during the last quarter of the cinquecento it was widely performed—at Pesaro, Urbino, Mantua, Florence, Rome, and Naples—and was to have a wide influence on pastoral drama both in Italy and other countries of Europe. The fa-

mous episode of Erminia in the *Gerusalemme* occurs in Canto VII, 1-22. (See R. W. Lee, "Erminia in Minneapolis" in *Studies in Criticism and Aesthetics 1660-1800 in honor of Samuel Holt Monk*, Minneapolis, 1967, pp. 36-56).

69. Cf. Canto XXIII, 110.

70. The engraving is after his brother, Teodoro (see Bartsch, XV, p. 410, no. 62). Ghisi, being a Mantuan, must have known Mantegna's frescoes in the Camera degli Sposi, as the ruin sprouting vegetation to the right and the natural arch suggest. The landscape as a whole represents in the last analysis an Italian domestication of northern landscape that the artist could have found in the engravings or paintings of Domenico Campagnola, the drawings of Pozzoserrato, born beyond the Alps, the engravings of Battista Pittoni of Vicenza, and the celebrated paintings of the Villa Maser where deep panoramic views of towns and harbors are combined with ruins. For discussion of this type of landscape, see A. R. Turner, *The Vision of Landscape in Renaissance Italy*, Princeton, 1966, chapters VII, VIII and X and the accompanying plates.

71. For the "slung leg motif," see L. Steinberg, "Michelangelo's Florentine *Pietà*: the Missing Leg," *Art Bulletin*, L (1968), p. 343.

72. See P. Pouncy and J. A. Gere, *Italian Drawings . . . in the British Museum, Raphael and his Circle*, London, 1962, pp. 95-96, no. 163.

73. The figure group in Ghisi's engraving was closely imitated in the signed and dated drawing which Aegidius Sadeler executed in Rome in 1693. In the 1965 catalogue of the Groningen Museum (no. 144, inv. no. B420), it is wrongly entitled *Paris and Oenone*. This is an example of the difficulty occasionally encountered, if the inscriptions on the trees are not legible, of distinguishing the ancient from the modern theme. It is also not unlikely that the Swiss-born artist, Joseph Heintz, who was in Rome in 1584 and again in 1593, adapted Ghisi's figure composition to his own uses in a black and red chalk drawing of *Angelica and Medoro* in the Albertina (*Die Zeichnungen der deutschen Schulen*, Vienna, 1933, p. 56, no. 453, Taf. 151).

74. The painting belongs, to judge by its format and style, to a series of erotic mythologies painted about 1580 for the Emperor Rudolph II (see *Deutsche und Niederländische Malerei zwischen Renaissance und Barock* [Alte Pinacothek, München, Katalog 1], Munich, 1961, p. 44). I am indebted to Konrad Oberhuber for calling this picture to my attention. For Vasari, see A. Blunt, *Artistic Theory in Italy*, Oxford, 1973, p. 92.

75. The version of the picture under discussion here is in the Barbieri

Collection, Padua. Not many years before it was described by L. C. Larcher in 1967 ("Per Carletto Caliari," *Arte Veneta*, XXI, pp. 108-109, fig. 119), it had returned to Italy, no doubt from Germany, where, as Larcher, to whom I am greatly indebted, observes (*ibid.*, p. 112 n. 14), Aegidius Sadeler had probably engraved it (Paris, Bibl. Nat. Ec 71a, 133). Another autograph version of the painting with differences in the treatment of foliage and of landscape is in the National Gallery of Prague (see the catalogue of the exhibition, *Venezianische Malerei 15. bis 18. Jahrhundert*, held in the Albertinum, Dresden, 25 April–25 June, 1968, pl. 19, and p. 44, where E. A. Šáfařík states incorrectly that the Prague version was engraved by Sadeler). An eighteenth-century version with altered landscape and details is in a private collection in Bologna. A pen and wash drawing in the Albertina by Johann Freyberger, who traveled to Italy in 1604, shows a clear adaptation of Carletto's group of Angelica and Medoro with their figures reversed (*Die Zeichnungen der deutschen Schulen*, p. 51, no. 403, Taf. 138).

Carlo Ridolfi, in his life of Domenico Tintoretto (1560-1635), mentions Ariosto subjects by this painter in his excellent, first manner in the "Casa Molina a San Gregorio" in Venice, one of them an *Angelica and Medoro* (see *Le maraviglie dell'arte* [first ed. 1648] ed. Hadeln, Berlin, 1914, II, p. 262). These paintings are lost, but the *Angelica and Medoro* might well have preceded Carletto Caliari's. This surely dates in the early 1590s when Carletto was in his early twenties. He died in 1596, aged 26 (*ibid.*, p. 353, n. 1). Ridolfi's statement that he painted *Angelica and Medoro* when only seventeen is scarcely credible.

76. Larcher (*op. cit.*, p. 108) suggests the influence of Paolo Fiammingo, whom Carletto may have known in Venice. But the panoramic landscape also recalls Domenico Campagnola (cf. note 70).

77. See Ridolfi, *op. cit.*, I, p. 354.

78. For the significance of torches held aloft, or held downward and extinguished, see R. W. Lee, "Van Dyke, Tasso and the Antique," in *Studies in Western Art: Latin American Art and the Baroque Period in Europe* (Acts of the Twentieth International Congress of the History of Art), Princeton, 1963, III, pp. 17-18.

79. See S. Béguin, *L'Ecole de Fontainebleau*, Paris, 1960, p. 122, for valuable stylistic diagnosis.

80. For Angelica's pose, see also C. de Tolnay, *Michelangelo*, II: *The Sistine Ceiling*, Princeton, 1945, pl. 90; for Medoro's pose many of the *ignudi* are suggestive (*ibid.*, pls. 95ff.).

81. See Agnelli and Ravegnani, *Annali delle edizioni Ariostee*, I, pp. 18-172.

82. For an excellent recent overview of the famous Ariosto-Tasso controversy and of the critical fortune of Ariosto from the sixteenth century on, see C. P. Brand, *Ludovico Ariosto, a Preface to the Orlando Furioso*, Edinburgh, 1974, pp. 181ff.

83. For Ariosto and the Pléiade, see A. Cioranescu, *L'Arioste en France des origines à la fin du XVIII^e siècle*, Paris, 1939, I, pp. 41-48. See also Alice Cameron, *The Influence of Ariosto's Epic and Lyric Poetry on Ronsard and His Group*, Baltimore, 1930. For the first French translations of Ariosto, see Cioranescu, *op. cit.*, I, chap. II.

84. Cioranescu, *op. cit.*, pp. 63ff.

85. For Ariosto in late sixteenth-century England, see note 156 below. For the influence of the episode of Angelica and Medoro on Spanish literature of the sixteenth and first half of the seventeenth centuries, notably on Lope de Vega, see M. Chevalier, *L'Arioste en Espagne (1530-1650)*, Bordeaux, 1966, especially pp. 229-232, 352-359, 413-417.

86. "Chant de l'amour et de l'hyver," in *Divers jeux rustiques*, ed. V. L. Saulnier, Lille and Genoa, 1947, no. XIX, p. 55. I am greatly indebted to Blanchard Bates for calling to my attention this and other examples of inscriptions on trees in the writings of the Pléiade.

87. *Ibid.*, no. XIV, pp. 22-23.

88. To Blanchard Bates, however, I am also indebted for an unusual example of the early sixteenth century where joyously, as in Medoro's case, Jean Salmon (*dit* Macrin) in a Latin ode, "Ad Petrum Borsalum," is busily engaged in carving not a mistress's (the usual case) but his bride's name, "Gelonis" (Guillonne Boursault), on the trunks of all the trees he encounters (see *Salmonii Macrini . . . Carminum libellus*, Paris, 1528, aii).

89. Ed. M. H. Vaganay, Lyons, 1927: for instance, III, 10, pp. 553-554, where "les chiffres bienheureux de nos noms" (those of Astrée and Celadon) are engraved on "le bassin qui recevoit la fontaine"; III, 12, pp. 654-655, where Silviane engraves her own name on a willow to which her admirer, Andrimarte, joins the words *j'ayme*; III, 7, p. 373, where Arimant, addressing Chryséide, opines that after his death his cruel mistress may perchance come upon his tomb, and seeing "les chiffres de nos noms" engraved on the surrounding trees, pensively recognize his ancient love. This passage derives from Tasso's *Gerusalemme Liberata*, Canto VII, where Erminia, who has engraved Tancred's name on various trees, ex-

presses the same sentiment. The *Astrée* was published in four parts, the last posthumously, between 1607 and 1627, the third part appearing in 1619. (The late Morris Bishop once remarked to me that lovers in the *Astrée* are forever scribbling on trees.) Compare the pastoral drama, *Les Bergeries*, III, 4, by Honorat de Bueil, Seigneur de Racan, published in 1625 (*Oeuvres*, ed. Tenant de Latour, Paris, 1857, p. 81), where Alcidor recalls happy days in the country:

> *Ces aliziers tesmoins de nos plaisirs passez*
> *Ont encor en leur tronc nos chiffres enlacez . . . ,*

and Saint-Amant, *La Solitude* (*Oeuvres*, ed. Jacques Bailbé, Paris, 1971, I, p. 41, 103-104), where again the tone is elegiac:

> *Ici l'âge a presque effacé*
> *Des chiffres taillés sur les arbres.*

90. E. Gombrich, *The Story of Art*, London, 1950, p. 308.

91. For the Villa Giovannina frescoes, see G. Atti, *Intorno alla vita e alle opere di Gianfrancesco Barbieri detto il Guercino da Cento*, Rome, 1861, pp. 36ff. Atti describes not only the Ariosto frescoes, but also two other series by Guercino in the villa, one portraying the story of Clorinda from Tasso's *Gerusalemme Liberata*, the other scenes from Guarini's famous pastoral drama, the *Pastor Fido*, published in 1590. See also Atti's *Sunto storico della Città di Cento*, Cento, 1853, pp. 101ff. In all three series, each in a single room, the scenes form a frieze of small frescoes running around the walls at the top.

92. See Stefano Bottari, *Guercino, Disegni*, Florence, 1966, p. 5, to whose comments I am here indebted.

93. Guercino's paintings of *Angelica and Medoro* were executed in 1642 and 1647 (see C. C. Malvasia, *Felsina Pittrice*, Bologna, 1841, II, pp. 323 and 328). Denis Mahon, in his superb catalogue of the exhibition of Guercino's drawings at Bologna, 1968, pp. 149-150, no. 159, is inclined to believe that his drawing (he has generously supplied me with a photograph) of *Angelica and Medoro* (Fig. 27), because it is close stylistically to others of the late 1640s, may well be a preparatory study for the painting of 1647, but that the other drawing discussed here (Fig. 28), which appears similar in style and was formerly in the collection of Sir Michael Sadler, is a less likely candidate. Mahon reports that his drawing bears a compositional relationship to a painting of *Angelica and Medoro* which he saw reproduced in an old photograph; the painting which has disappeared could be that of 1647. For the two drawings, see also Mahon's

remarks in *Omaggio al Guercino, Mostra di dipinti restaurati e dei disegni della Collezione Denis Mahon di Londra*, Cento, 1967, p. 51.

A seventeenth-century pen and wash drawing of *Angelica and Medoro* in the Uffizi (no. 3704) once attributed to Guercino, but certainly a school piece, shows the lovers seated on an inscribed tree stump; he embraces her and points to inscriptions on a tree.

94. The theme of Angelica and Medoro attracted several other Emilian artists of the early seventeenth century. Edoardo Fialetti's engraving is original in showing Angelica closely embracing Medoro as he carves on the flat top of a tree stump (see A. Bartsch, *Le Peintre graveur*, XVII, p. 275, no. 33; Paris, Bibl. Nat. YO A 21678). Trees behind them are inscribed with their names. Alessandro Tiarini in a heavy-handed picture in Dresden, with strongly-modeled but coarse figures, shows no talent for sensitive pictorial interpretation of Ariosto's pastoral; the half-length composition shows Medoro carving Angelica's name on the soft stone that forms the base of a fountain, while she points to inscriptions on a tree. The picture can reasonably be dated in the 1620s on the basis of the coldly monumental style that Tiarini practiced during that decade (see T. Fiori, "La prima attività Bolognese di Alessandro Tiarini," *Commentari*, VIII [1957], p. 112; the painting is reproduced in F. Malaguzzi Valeri, "Alessandro Tiarini," *Cronaca d'arte*, I [1924], p. 149). Also, Simone Cantarini of Pesaro, who was a pupil in Bologna of Guido Reni, painted an *Angelica and Medoro* which drew both praise and criticism from his master (see Malvasia, *op. cit.*, II, p. 373). Of an *Angelica and Medoro* by Reni himself mentioned by G. Hoet and P. Terwesten, *Catalogus of naamlyst van schilderyen, met derzelver pryzen . . .* , III, 1770, p. 640, no. 31, nothing is known. Domenichino's name has also been associated with the subject, but the painting attributed to him by Paul Dissard in his catalogue of the Musée de Lyons, 1912, p. 66, is now attributed to Cristofano Allori, and in any case represents Rinaldo and Armida, not Angelica and Medoro. Giuseppe Canacci in 1803 engraved as after Domenichino a half-length portrayal of Ariosto's lovers pointing to a tree inscribed ANGE E ME. Richard Spear, who saw an example of this in the Bibliothèque Nationale in Paris has kindly informed me that on the basis of the engraving the attribution to Domenichino appears false. Another late engraving of *Angelica and Medoro* after Domenichino by Giulio Tomba (1780-1841) is recorded by C. LeBlanc, *Manuel de l'amateur d'estampes*, Paris, 1888, IV, p. 44. I have not been able to locate this in Bologna or elsewhere.

95. I am obliged to his Grace, the Duke of Buccleugh, for permission to publish this picture.

96. One suggestion is a Roman painter of the mid-century; another, which appears more likely, is Livio Mehus, born in Holland, a pupil of Pietro da Cortona first in Florence, then in Rome, and twice a sojourner in Venice. The soft modeling, with delicate transitions of light and shade, a certain *non so che* of sentiment, the vibrant brush work used in painting the lapets of Medoro's sleeve and the feathers of Cupid's wings, as well as the modeling of Cupid's hands with marked horizontal brush strokes appear to show a relationship to similar aspects of style and feeling in such a painting by Mehus as the *Genius of Painting* (see H. Voss, "Zur Kritik des Velasquez-Werkes," *Jahrbuch der Preussischen Kunstsammlungen*, LV [1932], pp. 43-45, for an account of Mehus, and Abb. 1).

Another central Italian example of the subject of the second half of the century is a pen and wash drawing in Düsseldorf attributed to Ciro Ferri: the lovers are seated, and she carves the names (see I. Budde, *Beschreibendes Katalog der Handzeichnungen in der Staatliche Kunstakademie Düsseldorf*, Düsseldorf, 1930, p. 36, no. 255 [283]).

97. See *La Pittura del seicento in Venezia, Catalogo della Mostra*, Venice, 1959, p. 75, no. 115, and C. Donzelli and G. M. Pilo, *I Pittori del seicento Veneto*, Florence, 1967, pp. 233-238.

A sepia drawing heightened with white by Antoine Rivalz of Toulouse (1667-1735) in the Musée Paul-Dupuy of that city is iconographically original in showing a *putto* guiding Medoro's hand as he carves Angelica's name. The figures seated together and accompanied by *putti* are arranged diagonally to fill most of the picture space on the right, an old Venetian formula, as we have noted above, and already employed for this subject by Pietro Liberi (cf. Figs. 30 and 31). Rivalz was in Rome from 1687-1701, enough time to have permitted a journey or two to Venice (see *Inventaire général des dessins des musées de province*, II, *Toulouse, Musée Paul-Dupuy* . . . , 1958, fig. 131 and index).

98. See E. Panofsky, *Problems in Titian*, pls. 110 and 182. For the *Nymph and Shepherd*, which to Panofsky suggests Ovid's Paris and Oenone, see his beautiful interpretation, *ibid.*, p. 169.

99. Anthony Blunt, *Art and Architecture in France, 1500 to 1700* (Pelican History of Art), Baltimore, 1954, p. 171.

100. A nearly identical picture by Blanchard belonging to the Earl of Mount Edgcumbe was destroyed during the last war (see *Exhibition of Seventeenth-Century Art in Europe*, London, Royal Academy, 1938, II, pl. 79). The New York picture, which, unlike the other, shows Angelica entirely nude, was engraved by Voiez l'Aîné in 1771 and again by Le Grand in the Cabinet Poullain, 1781. The motif of both carving

does not seem to have been repeated again until the late eighteenth century in a neoclassic composition by Teodoro Matteini, a pupil of Pompeo Batoni and Mengs, engraved in oval form in Rome by Raphael Morghen in 1795 (Le Blanc, III, p. 51, no. 58). Here both hold the same knife as they carve, Medoro seated and showing a classical profile, while Angelica, leaning across Medoro's knees, is seen from behind in a posture (with her profile accentuated) clearly suggested by the figure of Hebe in the *Marriage Feast of Psyche* in the Villa Farnesina. The engraving is in the Bibliothèque Nationale in Paris; Matteini's invention was also engraved by Giovanni Folo (*ibid.*, II, p. 243, no. 27) and in 1797 by Andrea Freschi (an example is in the Berlin Kupferstichkabinett). A late eighteenth-century oval watercolor on parchment after the Morghen engraving is in the Walters Art Gallery, Baltimore.

101. For Poussin's sojourn in Venice in 1623-24 on his third and successful attempt to reach Rome, see D. Mahon, "Nicolas Poussin and Venetian Painting," *Burlington Magazine*, LXXXVIII (1946), pp. 15-20, 37-42. Basing his argument on the notes on Poussin added by Giulio Mancini to his *Considerazioni sulla pittura*, Mahon concludes that Poussin visited Venice between the summer or early autumn of 1623 and the spring of 1624, before continuing his journey to Rome.

102. For this dating I am indebted to Konrad Oberhuber, who is making a study of the paintings and drawings of Poussin's early period, and has convincingly reattributed this drawing to Poussin. He expects to publish the results of his study in the near future. The early attribution to Poussin was rejected by Friedlaender and Blunt (*Drawings of Nicolas Poussin*, London, 1953, III, p. 40), who suggested that it was probably by Blanchard; it was given by Richard Cocke to Pier Francesco Mola, I now believe for insufficient reasons ("A Note on Mola and Poussin," *Burlington Magazine*, CXI [1969], p. 712). In her review of Cocke's recent book on Mola (*Pier Francesco Mola*, Oxford, 1972), Ann Sutherland Harris has rejected the attribution to Mola (*Art Bulletin*, LVI [1974], p. 291, n. 8).

103. A variant of this picture, colder in feeling, and, I should say, not autograph, was on the Paris art market about four decades ago. An extra *putto* hangs over the branch above the lovers' heads, and the composition has been expanded to the right to include a large tree.

104. See Cioranescu, *L'Arioste en France*, II, pp. 28-32.

105. *Ibid.*, II, pp. 52-55.

106. *Réflections critiques sur la poésie et sur la peinture*, Paris, 1719, I, pp. 279-281.

107. Charles de Brosses, *Lettres historiques et critiques sur l'Italie*, Paris, 1804, III, letter V (to M. de Neuilly), pp. 128-130. The letters were written in 1739-40.

108. In his *Essai sur la poésie épique* (written first in English ca. 1726 when he was in England, translated into French in 1728), *Oeuvres*, ed. L. Moland, VIII, p. 337 (text of 1733).

109. *Loc. cit.*, note 1 (text of 1742).

110. For Bettinelli, see Raffaello Ramat, *La critica ariostesca*, Florence, 1954, pp. 71ff. He visited Voltaire at Ferney in 1758.

111. Letter to Chamfort, 1774, *Oeuvres*, XLIX, p. 120.

112. Cioranescu, *op. cit.*, II, p. 125. For a full account of Voltaire vis-à-vis Ariosto, see pp. 119-141.

113. "Don Pêdre, Epître dedicatoire," *Oeuvres*, VII, p. 245.

114. *Oeuvres*, XVIII, p. 579.

115. In his *Tasso*, Act I, Scene 1, 13-19; Scene 4, 140ff.

116. De Launay lived from 1739 to 1792. The engraving must date well into the second half of the century. Another early eighteenth-century painting by François Marot (1666-1719) was engraved by Jean Moyreau. Here Medoro, standing beside a seated Angelica, points out the names carved on a massive tree trunk, while a cupid appears to do the same (Le Blanc, III, p. 60). The engraving is in the Bibliothèque Nationale. Raoux was born in 1677 and became a member of the Academy in 1717 (see P. Marcel, *La Peinture française au début du dix-huitième siècle, 1690-1721*, Paris, n.d., p. 131, fig. 39 and *passim*). His *Angelica and Medoro* was painted in Italy or perhaps shortly after his return to France in 1714. Cf. Thieme-Becker, *Künstlerlexicon*, XXVIII, pp. 14-15.

117. Venice was frequently visited by young French painters during the late seventeenth and early eighteenth centuries when Venetian color and composition were becoming important in French painting as reinforcement for the practice of the Rubénistes. Charles de la Fosse had passed three years in Venice as early as the 1760s, and Watteau's affinity for Venetian painting is well known. Already in 1668, fifteen years before he published his *Dialogue sur le coloris*, Roger de Piles in his commentary on Du Fresnoy's *De Arte Graphica*, praises the great Venetian painters along with Rubens. In 1699, in his *Abrégé de la vie des peintres*, he remarks, apropos of the excellence of Titian's color, that he has always been in that regard "la boussole des véritable peintres." See Marcel, *op. cit.*, p. 55.

118. The slung leg in Raoux's painting particularly recalls its use in Jacopo Caraglio's engraving after Perino del Vaga's drawing of *Neptune and Doris* (Fig. 35; cf. also his *Hercules and Deianira*). See A. Bartsch,

Le Peintre graveur, xv, p. 73, no. 11 (Bartsch calls the engraving *Neptune and Thetis*), and p. 75, no. 19. Raoux could also have seen during his Italian sojourn Vincenzo de Rossi's *Theseus and Helen* in the Boboli Gardens (see A. Venturi, *Storia dell' arte italiana*, x, pt. 11, fig. 263).

119. The first cartoon (1.31 x 1.94m.) was on the Paris art market at the Hotel Drouot in November, 1973. I am greatly obliged to David Duvivier for calling it to my attention. The second, painted later in 1733 (Fig. 37) to serve as actual model for the tapestry executed the following year, is longer in proportion and naturally much larger than the first (3 x 6.15 m.); it is now in the Musée National du Chateau de Compiègne and was engraved by Pierre Surugue in 1737. See M. Fenaille, *État général des tapisseries . . . des Gobelins*, Paris, 1904, ser. 3, vol. 11, pp. 323 and 325-326; also F. Engerand, *Inventaire des tableaux commandés et achetés par la direction des Bâtiments du Roi (1709-1792)*, Paris, 1900, pp. 121-122.

120. See F. Boucher, *Recueil de fontaines inventées par François Boucher*, Paris, 1735, *passim*, and especially pl. 4.

121. Especially the attractive quarto and folio editions published by Antonio Zatta, Venice, 1772, with full-page illustrations for each canto, designed by Pier Antonio Novelli, and minor Venetian artists; the famous edition of John Baskerville, Birmingham, 1773, with illustrations by Cipriani, Moreau *le jeune*, Cochin *fils*, Monnet, Greuze, and others; and of Brunet and Laporte, 1775-83 (with the prose translation by d'Ussieux) where the Baskerville illustrations are repeated and a new set added after the designs of Charles Nicolas Cochin *fils*, the latter being repeated in the edition in Italian published by P. Plassan, Paris, 1795 (see Agnelli and Ravegnani, *Annali*, i, pp. 199-212, ii, p. 289; U. Bellocchi and B. Fava, *L'Interpretazione grafica dell' Orlando Furioso*, Reggio Emilia, 1961, pp. 29-36).

122. Reproduced also in Bellocchi and Fava, *ibid.*, tav. XXXVIII.

123. Pierre Pasquier, Salon of 1771, Livret no. 26, p. 28, no. 126; Simon Julien, 1787, Livret no. 34, p. 40, no. 189 (dessin) and cf. Le Blanc, i, pp. 636-637, no. 43, for an engraving after Louis de Silvestre by Guillaume Chasteau. An earlier painting by Antoine Pesne, signed and dated 1751, is in the National Museum in Warsaw. In a bucolic setting Medoro carves Angelica's name, while she reclines beside him. Both, in elegant costume, seem to have stepped into the country from an eighteenth-century stage (see the *Catalogue*, 1938, p. 48, no. 79, pl. 49). A late century (ca. 1780) example (if it is not a *Venus and Adonis*) is Louis Gauffier's atrocious neoclassic version (falsely melodramatic for an *An-*

gelica and Medoro) in a private collection in Paris (see Cioranescu, *L'Arioste en France*, II, pl. xii).

124. Livret no. 23, p. 12. See A. Michel, *Boucher*, Paris, n.d., pp. 120-122. I have not seen this picture and must depend on a photograph for its description.

125. *Vite de' Pittori, Scultori ed Architetti Moderni*, Rome, 1930, I, p. 231.

126. See F. Dowley, "Some Drawings of Benedetto Luti," *Art Bulletin*, XLIV (1962), p. 231 and figs. 13-14; and cf. A. Clark, *Art Bulletin*, XLV (1963), p. 59. Louvre no. 1271 is here reproduced (Fig. 39); no. 1272 (Dowley, fig. 14) is in a more conservative style with quiet postures and crisper, less fluid outlines. The third Louvre drawing, no. 6302, formerly attributed to Donato Creti, was restored to Luti by Clark. For the Uffizi example, see G. V. Castelnovi, "Settecento minore," in *Studies Dedicated to William E. Suida*, London, 1959, p. 335, fig. 8.

127. See Dowley, *op. cit.*, p. 228; and for Rocca's relation to Luti, see also Castelnovi, *op. cit.*, pp. 333ff.

128. I am indebted to Edward S. King for this and other valuable information concerning Rocca.

129. For Rocca's other versions of this picture (those of later date have no *putti* in the air), see the list, with bibliography, of B. Klesse, *Katalog der italienischen, französischen und spanischen Gemälde bis 1800 im Wallraf-Richartz-Museum*, Cologne, 1973, p. 111, no. 2420, and for the late version in this museum, fig. 54. Dr. Klesse does not, however, refer to the early version in the Walters Art Gallery discussed here (first attributed to Rocca by W. E. Suida in a letter of 1943), the provenance of which is unknown. One version almost identical with the Walters picture is in the National Gallery, Prague; another which appears to be a replica of poor quality was formerly in a private collection in Köln-Deutz.

130. See T. Ionescu, "Ein Ricci-Gemalde," *Neuer Weg*, n. 5304, Bucharest, May 21, 1966 (I am greatly indebted to M. Ionescu, Director of the Bruckenthal Museum at Sibiu, for sending me a copy of his excellent article); also P. Zampetti, *Dal Ricci al Tiepolo* (catalogue of the exhibition at Venice, 1969), p. 34, no. 13.

Another charming Venetian idyll of Angelica and Medoro, perhaps a little earlier in date, is Giovanni Antonio Pellegrini's canvas in the Clemens-Sels Museum at Neuss; Medoro carves while Angelica nestles at his side (see *Wallraf-Richartz-Jahrbuch*, XXV [1963] Abb. 225). In a painting of the early years of the eighteenth century by the Ferrarese painter,

Giuseppe Zola, Angelica writes "t'amo" on a tree (see E. Riccomini, *Settecento Ferrarese*, Milan, 1970, p. 46, no. 74).

131. See J. R. Martin, *The Farnese Gallery*, Princeton, 1965, pl. 69. My thanks go to Elaine Banks for identifying the Carracci *putto* as Ricci's source.

132. See Ashmolean Museum, Oxford, *Report of the Visitors*, 1956, pp. 58-59.

133. Two other drawings of the subject by Giambattista, both of the 1740s are in the American collections of Eugene Thaw at Alpine, New Jersey (see R. W. Lee, "Giambattista Tiepolo's Drawing of Rinaldo and Armida," *Bulletin of the Smith College Museum of Art*, no. 41, 1961, p. 18 and fig. 10) and of the National Gallery of Art, Washington, Rosenwald Collection (see A. Miller, *The Drawings of Tiepolo*, London, 1956, pl. 20).

134. Cf. note 53 above. Three decades after Tiepolo's frescoes, Giuseppe Ghedini of Ferrara painted an elegant *Angelica and Medoro*, dated 1788, which is in the Mazza Collection of that city. The picture, reminiscent of both Venetian eighteenth-century painting and of François Boucher, depicts Angelica seated on the ground and leaning against Medoro whose left arm rests on a large rock on which the names are carved. The figure group is in the long tradition of many paintings of the subject, as well as of Tasso's Rinaldo and Armida and of various erotic mythologies (see E. Riccomini, *Settecento Ferrarese*, pp. 29, 65, tav. xx).

135. There is a drawing by Giandomenico in the Brera Gallery (no. 2177). For the Ashmolean example here reproduced (Fig. 47) see K. T. Parker, *Catalogue of the Collection of Drawings*, ii (Italian schools), p. 543, no. 1098. See especially the catalogue of the sale of drawings by Giandomenico, the property of Earl Beauchamp, held at Christie's, London, June 15, 1965, pls. 132-139. Plates 130 and 131 are very expressive drawings of Angelica tending Medoro's wounds (see notes 49 and 53 above).

136. West's biographer, John Galt, in his *Life, Studies and Works of Benjamin West, Esq.*, London, 1820, i, p. 142, remarks that he painted in Rome "a picture of Cimon and Iphigenia, and, subsequently, another of Angelica and Medoro." Galt says later (ii, p. 6) that in the first house he occupied in London, West painted his first picture done on English soil, "an Angelica and Medora (*sic*), which with the Cymon and Iphiginia (*sic*) painted at Rome . . . he sent to the exhibition in Spring Gardens in 1764." There seems to be some confusion here. Then, in Galt's appended catalogue of West's works (ii, p. 226) we read "Do. of Cymon

and Iphigenia and Angelica and Medora in the possession of Mr. Mitton of Shropshire, painted in Rome." The Binghamton picture, then, may well be the version painted in Rome, which West, as I have suggested, finished in England. Galt further confuses the matter by mentioning in his catalogue with no dates three other examples of the subject (II, pp. 221, 224, 228). For West and Angelica Kauffmann, see *Angelica Kauff-mann*, an unpublished dissertation by Peter Walch, Princeton University, 1969, pp. 16ff. For the Binghamton picture, cf. H. von Erffa, "Benjamin West: the Early Years in London," *American Art Journal*, v, no. 2 (1973), pp. 4-14. The painting, von Erffa kindly informs me, was engraved by Earlom in 1768 and by Facius in 1768 and 1778.

Kauffmann, a frequent illustrator of Tasso, has also been credited with a hand at least in six paintings (intended for overdoors) at Nostell Priory in Yorkshire which are said to depict scenes from the story of Angelica and Medoro (see M. W. Brockwell, *Catalogue of the Pictures . . . at Nostell Pirory*, London, 1915, pp. 105, no. 3; 113, nos. 11 and 12; 123, nos. 22 and 23; 130, nos. 20 and 30; cf. p. 131). Only the first of these (no. 3) is related to Ariosto's account; it shows Medoro in armor(!) inscribing Angelica's name on a tree while she reclines on a bank nearby. The inscription "Angelica Me . . ." might also be taken as the artist's signature. The other five scenes as described in Brockwell's book indicate no connection with Ariosto's text, but perhaps, though badly understood, with Tasso's story of Rinaldo and Armida. An *Angelica and Medoro* ascribed to Angelica Kauffmann, which shows Ariosto's heroine reclining between Medoro's knees and both of them carving, attended by a cupid, appeared in the Wesendonck Sale, Lepke, Berlin, October 27, 1925. At Nostell Priory an earlier painting by Willem van Mieris the elder, signed and dated 1720, may well be, from the description given which suggests the *Paris and Oenone* in the Wallace Collection, a portrayal of that subject rather than of Angelica and Medoro, the title given it by Waagen (Brockwell, *op. cit.*, p. 292, no. 286).

137. E.g. the edition of Nicolò Bettoni, Milan, 1821, with engravings of little consequence by Filippo Pistrucci, and the folio edition of one hundred engravings by Bartolomeo Pinelli, Rome, 1828.

138. See the illustrations in the editions of A. and S. Battelli, Florence, 1844, by Giuseppe Gozzini, and in the French translations by Mazuy and Philipon de la Madelaine, published respectively in Paris by F. Knab, 1839, and J. Mallet, 1844.

139. The scenes of Angelica tending Medoro's wounds occur from the Paris, 1775-83 edition with the illustrations of Cochin through various

editions of the Conte de Tressan's French translation, e.g., Paris, 1788, 1796 and 1822, to the Knab, 1839, and Mallet, 1844, editions as well as in some more recent.

140. The year of the romantic edition cited in note 138 which is richly and elegantly illustrated with three hundred vignettes and twenty-five full-page plates by Tony Johannot, H. C. A. Baron, F. L. Français and C. Nanteuil. Despite their energy and scenographic virtue, the famous illustrations of Gustave Doré in the edition of Hachette, Paris, 1878-79, reflect a wild and often hideous imagination—for the artist, as has been well said, "tutto sacrifica al demone della propria esuberanza,"—which often does extreme violence to Ariosto's subtlety, airy fantasy and sense of beauty. For Doré, see Bellocchi and Fava, *L'Interpretazione grafica dell' Orlando Furioso*, pp. 42ff., and for Ariosto book illustration in the nineteenth and twentieth centuries, pp. 37-53, and accompanying plates.

141. See the *Livrets des Salons* for citations of Angelica and Medoro: 1806: A. C. Fleury, p. 36, no. 197; 1810: A. J. J. E. A. Ansiaux, p. 1, no. 7; R. T. Berthon, p. 8, no. 64; J. D. Paul, p. 79, no. 631; 1812: J. Ducq, p. 36, no. 333; 1814: Berthon, p. 8, no. 75; Ducq, p. 36, no. 359; J. Gudin after Berthon (engraving), p. 124, no. 1272; 1817: A. F. Lesage, p. 58, no. 526; 1822: P. Franque, p. 61, no. 500; Mlle. Fontaine, p. 58, no. 477; 1849: F. Bouterwek, p. 29, no. 235; E. Naissant, p. 135, no. 1532. But of these examples, those by Berthon, Gudin and Franque are described as representing Angelica tending Medoro's wounds on the battlefield while those of Ducq and Mlle. Fontaine depict *Le Mariage d'Angélique et Médor*. Only those of Fleury and Lesage are described as showing the carving of names, while those of Ansiaux and Paul, at the century's beginning, and those of Bouterwek and Naissant at mid-century are merely listed as *Angélique et Médor*; since all the others are precisely described, these perhaps may be presumed to have portrayed the more common scene of carving names, but one cannot be certain.

142. See *Musée Magnin*, Dijon, 1938, p. 96, no. 413. Lorenz Eitner has kindly informed me that there are many sketches of this kind which have been attributed by their owners to Géricault, but that to attribute to him a sketch like that at Dijon "without strong confirming evidence of a documentary sort . . . is purely an act of faith."

143. The cartoon for the fresco shown here in Fig. 50 was made early in 1825, and the fresco completed in April-May of that year. Below Angelica and Medoro we see Orlando despondent and, at the lower right, *furioso*, while the lovers ride away upper right. For the decoration of the Casino Massimo one room was entrusted to Cornelius, then to Veit and

Koch, a second to Overbeck and Führich, a third to Schnorr von Carols-feld. Their tasks were respectively to glorify Dante, Tasso and Ariosto by painting scenes from their most famous poems. See K. Gerstenberg and P. O. Rave, *Die Wandgemälde der Deutschen Romantiker im Casino Massimo zu Rom*, Berlin, 1934; for the Ariosto room, pp. 146ff. and pls. 42-56; the Angelica and Medoro cartoon, p. 123, fig. 102 and page 181, no. 41; a pen drawing in Leipzig, "Angelica et Medore," dated "14. Octob. 22," p. 167, fig. 156; a pen and wash drawing also in Leipzig, p. 183, fig. 165.

144. J.-V. Bertin, Salon of 1833, p. 13, no. 159; H. J. A. Cambon, Salon of 1857, p. 49, no. 428. An exception is the nineteenth-century romantic painter, Giovanni Carnovali (Il "Piccio"), 1804-1873, whose large oeuvre includes many mythologies and literary subjects. Among the latter are four from Ariosto, all depicting Angelica and Medoro, which date from ca. 1835 to ca. 1860. In the earliest Medoro carves, in the others, lyrical variants on a theme, Angelica. She reclines beside Medoro and throws her right arm in an arc across his body. For illustration see C. Caversazzi, *Giovanni Carnovali, Il Piccio*, 3rd ed., Bergamo, 1946, tav. CCLIII-CCLV; M. Valeschi, F. Rossi and B. Lorenzelli, *Il Piccio e artisti bergamaschi del suo tempo*, Catalogue of the Exhibition of his work at Bergamo, 1974, p. 45, fig. 17; p. 81, fig. 54; and cf. p. 41, fig. 13.

145. See the list in Rouchès, "L'Interprétation du Roland Furieux dans les arts plastiques," *Études Italiennes*, II, 1920, p. 139.

146. By R. Poggioli in *The Oaten Flute*, Cambridge, 1975, pp. 31-32.

147. "The Happy Shepherd" (1889).

148. The only reference to the story is the drawing that shows Orlando discovering the names of the lovers carved in the rock (Canto XXIII, 107, 111). See Mongan, Hofer, and Seznec, *Fragonard Drawings for Ariosto*, plate 126. Compare notes 35-36 above.

149. See G. Wildenstein, *The Paintings of Fragonard*, London, 1960, p. 285, no. 390, fig. 81.

150. *Ibid.*, p. 284, no. 389.

151. In the collection of Dr. and Mrs. Irving Levitt, New York (see the *Retrospective Exhibition of Winslow Homer*, Boston, 1959, p. 18, fig. 4). I am indebted to W. Roy Fisher of Wildenstein and Co., New York, for providing a photograph.

152. See J. Magnin, *Cabinet d'un amateur parisien en 1922*, Dijon, 1922, II, p. 256, no. 428, reproduced p. 257; also the catalogue, *Musée Magnin*, Dijon, 1938, p. 136, no. 609. The Magnin Collection is now in the Musée de l'Art, Dijon.

153. See Sacheverell Sitwell, *Narrative Pictures*, New York and London, 1938, pp. 83-84, fig. 121; new edition, New York, 1972.

154. See E. Hyams, *Capability Brown and Humphry Repton*, London, 1971, p. 143, fig. 18.

155. See *A. B. Durand, 1796-1886, Exhibition at the Montclair, New Jersey, Art Museum*, October-November, 1971, p. 59, no. 56, illustrated on p. 36.

156. Act III, Scene 1, 9. In Spenser's *Faerie Queene*, IV, 7, 46 (1596), Timias, the gentle squire, several years before Shakespeare's Orlando, had carved the name of his lady, Belphoebe, on "every tree." For the whole episode, which has been called "the most remarkable of Spenser's borrowings from Ariosto" just as it is surely the most subtle and original transformation of the story of Angelica and Medoro in any language, see the perceptive commentary in P. J. Alpers, *The Poetry of the Faerie Queene*, Princeton, 1967, pp. 185-194. Spenser's main changes in Ariosto's story are in transferring "Angelica's role as the love-stricken one" to Timias, and in portraying his love as unfulfilled. By contrast, the other Elizabethan adaptation of the *Orlando Furioso* in which Angelica and Medoro appear is a vast distortion of Ariosto's fable. This is Robert Greene's play, *The Historie of Orlando Furioso* (first performed, 1594) in which Sacripant, to arouse the jealousy and rage of Orlando, his rival for Angelica's hand, contrives to have trees engraved with the names of Angelica and Medoro; he is here a page accompanying her, but is not in love with her, nor she with him. Orlando after seeing the names, shortly goes mad, is later restored to sanity, and marries Angelica, who had chosen him from the beginning. For Ariosto and the Elizabethans, see A. Sammut, *La fortuna dell' Ariosto nell' Inghilterra Elizabettiana*, Milan, 1971: for Spenser's adaptation of Angelica and Medoro, pp. 69-70; for Robert Greene, pp. 108-113; for *As You Like It*, p. 113; for Elizabethan translations, including Sir John Harrington's famous version of 1591 of the entire *Orlando Furioso*, pp. 90ff. Cf. also A. Benedetti, *L' "Orlando Furioso" nella vita intellettuale del popolo inglese*, Florence, 1914, especially pp. 125-126, 175-179.

157. *Thoughts in a Garden*, stanza 3 (published in 1681 after his death).

158. *Tom Jones* (1749) bk. v, chap. 10.

159. From *Horae Lyricae* (1706). I am greatly indebted to my generous friend, Samuel H. Monk, for calling my attention not only to this remarkable use of the motif but to other examples of it in English poetry of unusual interest, e.g. in Robert Herrick's charming and gently mock-

elegiac poem, "To Groves" (1648), where the poet invokes the "silent shades" whose trees, carved with the names and complaints of wounded hearts, are the "Legend of those Saints that died for love," and in James Thomson's *The Seasons, Summer* (ed. of 1744), 1261-1362. Here Damon spies Musidora bathing, and leaves her a note on the bank of the stream; when it catches her eye and she knows she has been discovered, she resembles the Medici Venus (now in the Uffizi) in her posture of shamed modesty. But finally recognizing Damon's handwriting, she ceases to be alarmed.

> *Even a Sense*
> *Of self-approving Beauty stole across*
> *Her busy thought.*

(How well the poet expresses the statue's double-entendre!) Then in time-honored bucolic fashion she writes a confession of "Rural Loves" with "silvan Pen" on a "spreading Beech." See also Alexander Pope, *Pastoral*, III, Autumn (1709), 65-70, for a rather pallid elegiac version.

160. I am grateful to Josepha and Kurt Weitzmann for these examples. The motif also occurs in Eduard Möricke's beautiful poem *An eine Lieblingsbuche meines Gartens, in deren Stamm ich Hölty's Namen schnitt,* which Erwin Panofsky long ago called to my attention.

161. See F. Stampfle and J. Bean, *Drawings from New York Collections,* II, *The Seventeenth Century in Italy,* New York, 1967, p. 45, no. 56, for interesting comment on the drawing's history and quality.

Index

Library of Congress Cataloging in Publication Data

Lee, Rensselaer Wright, 1898–
 Names on trees.

 (Princeton essays on the arts; 3)
 Includes bibliographical references and index.
 1. Names carved on trees. 2. Ut pictura poesis
(Aesthetics) 3. Ariosto, Lodovico, 1474-1533.
Orlando furioso—Illustrations. I. Title.
N66.L4 1977 760 76-3270
ISBN 0–691–03914–3
ISBN 0–691–00311–4 pbk.